TAO OF

PHOTOGRAPHY

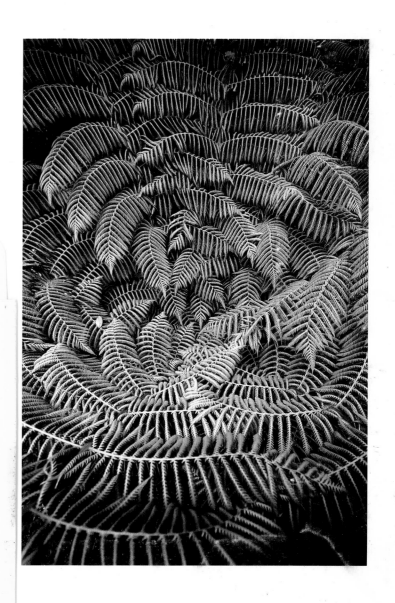

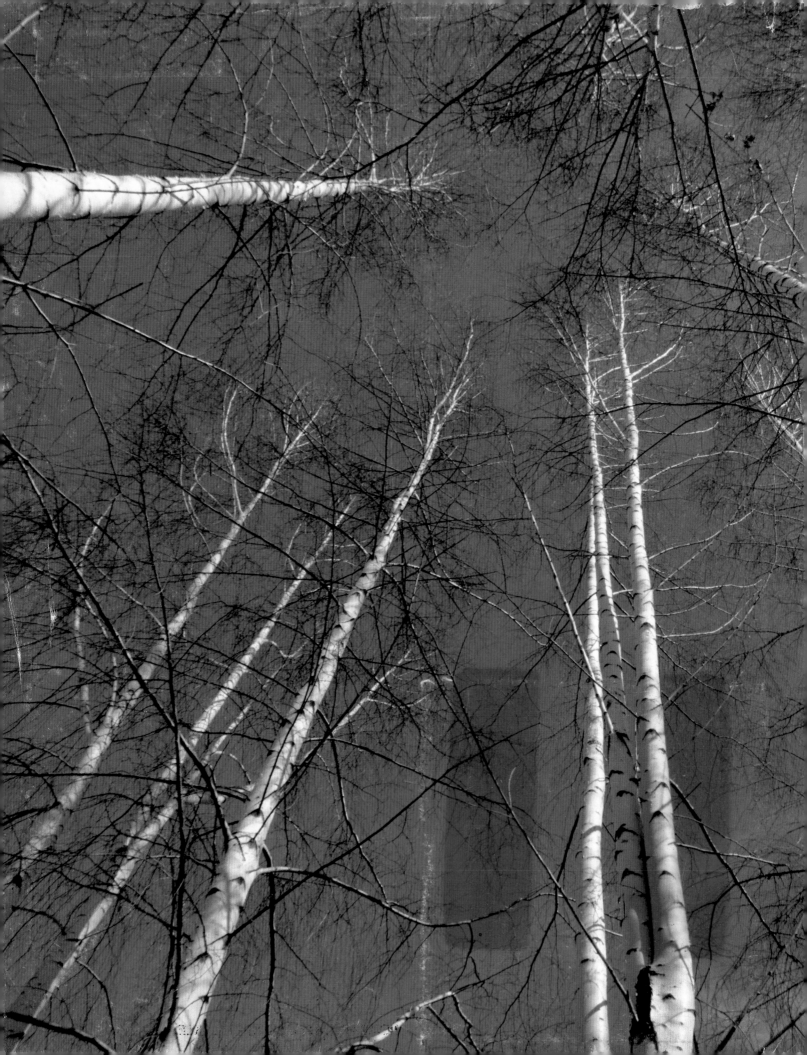

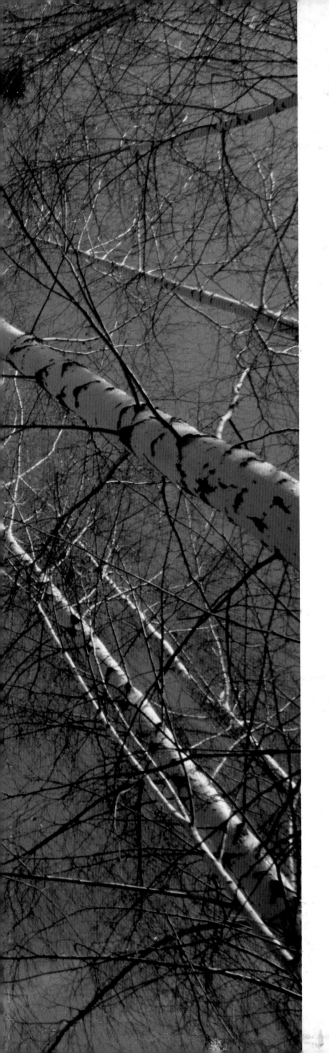

TAO OF

PHOTOGRAPHY

TOM ANG

AMPHOTO BOOKS

An imprint of Watson-Guptill Publications

New York

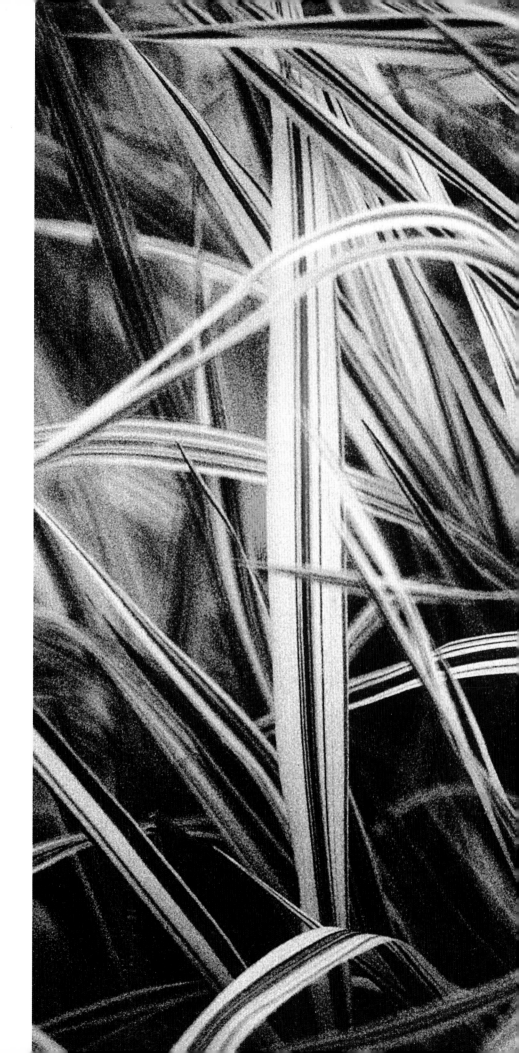

Tao of Photography

I dedicate this book to my parents Mary and Boo Soke

Text © Tom Ang 2000

Design copyright © Octopus Publishing Group Ltd 2000

All photographs and digital images © Tom Ang 2000

First published in the United States in 2000 by
Amphoto Books, an imprint of Watson-Guptill Publications,
a division of BPI Communications, Inc.,
770 Broadway, New York, NY 10003

Executive editor **Judith More**
Executive art editor **Janis Utton**
Designer **Jeremy Williams**
Project editor **Michèle Byam**
Contributing editor **Jonathan Hilton**
Production controller **Nancy Roberts**
Indexer **Laura Hicks**

Library of Congress Card Number: 00-100636
ISBN: 0-8174-6004-7

First published in 2000 by Mitchell Beazley,
an imprint of Octopus Publishing Group,
2–4 Heron Quays, London E14 4JP

Set in Univers
Printed and bound in China

First printing 2000
1 2 3 4 5 6 7 8 9 / 08 07 06 05 04 03 02 01 00

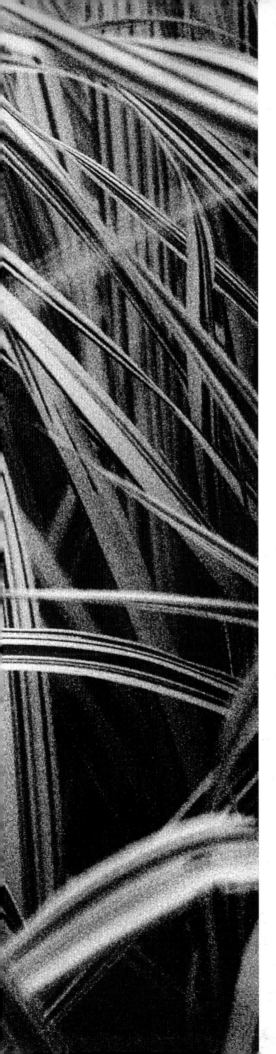

Contents

Introduction

We are fortunate to be living in the age of photography's renaissance. Photography is an energetic and powerful process of communication. But it is also valuable in enabling us to connect with ourselves, a way of making sense of our existence and of enjoying the world – though it is equally able to distort our thinking. How we photograph therefore impacts not only on our own lives, but also on the lives and experience of others – it even impacts on the wider environment in which we live. At the same time, photography has been lifted up and turned over by an infusion of new energy and new techniques – its horizons enlarged by digital photography.

For many years I have searched for an approach that could bring together the technical processes of photography with the richness of human creativity, an approach that could locate photography's role in the wider arena of communication. The approach I envisage blurs the distinction between photography and other activities: for a start, photography's power to communicate and its right to free expression carry with them the responsibility of ensuring that benefits flow between the photographer and the photographed.

Furthermore, I believe that there is a way to understand the dual nature that is inherent in photography: its ability to tell lies as effectively as its ability to reveal hidden truths; its power to cause nausea and pain or to enchant and delight. The great thirteenth-century Persian poet Rumi wrote that no art or craft begins or can continue without a master giving wisdom into it. I called widely on the greatest thinkers, as well as photographers and artists, to give their wisdom into photography. I found the richest and most resonant to be the the ancient traditions of wisdom centered on Tao or "the Way." As a result, this book is an exploration of what happens when technological understanding partners Taoist thought-processes. Interestingly, via Taoist thinking we obtain a perspective on photography that shows its great capacity for personal fulfilment; simultaneously we are reminded that we have been entrusted with a means of communication of great power. Capable though it is of facilitating evil, we can also turn photography to considerable good. With Tao as the background, we can see that photography's greatest talent, and its biggest responsibility, is to prove that beauty and wholeness are worth preserving.

I hope to show that the route to photography via Tao can link creative understanding with the appropriate technology. The book, however, is not an exposition of Tao. But if you comprehend even a small corner of Tao, it can illuminate your photography – its practice and the mental process involved. You can deduce from the word of great artists that they, too, were touched by Tao. Even if they did not know it, Tao informed and flowed through their work and lives. The advantage you have is that you can live and develop your work with Tao: the understanding will also regenerate your love and enthusiasm for photography. This is the entirety of the book's aim.

Tom Ang, London

Right: A constantly changing kaleidoscope of colors, textures and calligraphic arrangements under the brilliant light of an equatorial midday turned a rock pool on Bawe Island, Zanzibar, into a miraculous art show. Any number of pictures could have emerged from this scene. ■Canon EOS-1n with 28-135mm lens @ 85mm; f/8 at 1/125sec; ISO 100 film.

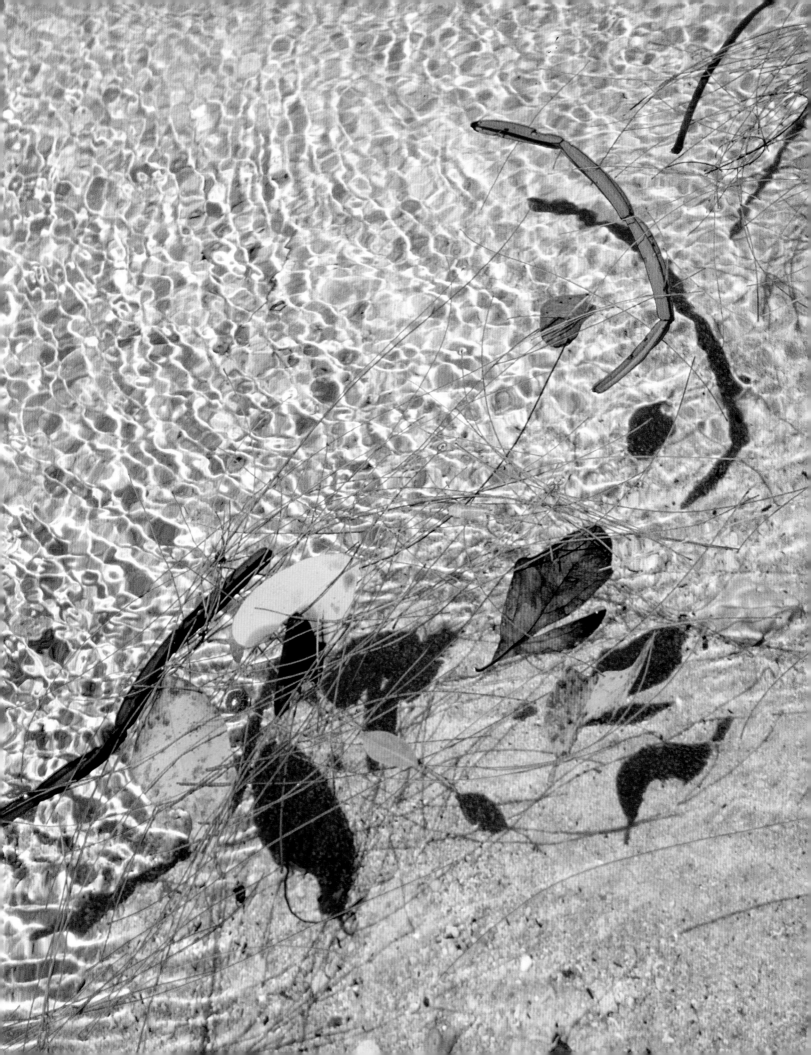

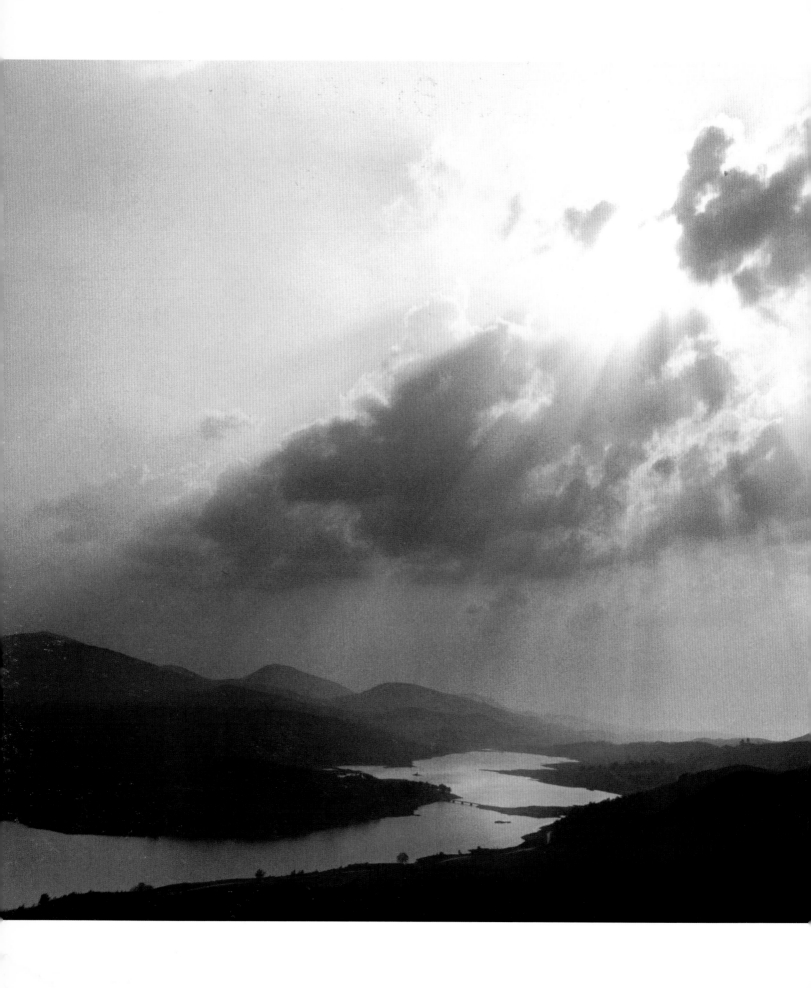

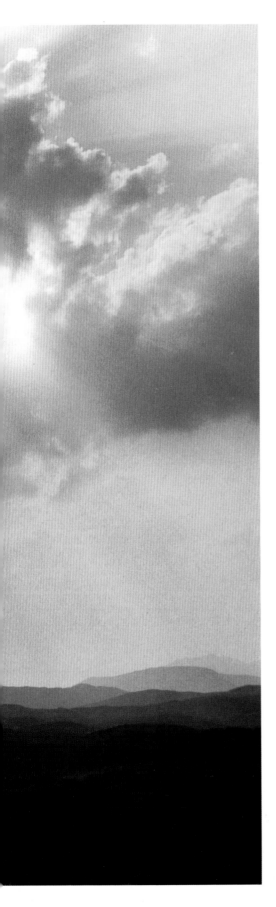

Balance and awareness

Tao illuminates photography by giving us one fundamental principle — the Way in harmony with all — to guide our work. However, you do not have to learn any spiritual exercises or live abstemiously — although in as much as these improve your health, they all help. Rather, Tao offers the photographer a new perspective, one that looks both from above and from within. It leads to a greater photography, both in understanding and in satisfaction.

In as much as photography consists of a long and irregular line of decisions, it is essentially about harmonizing or finding a balance between the pros and cons of one action as opposed to another. All photographers make these decisions so often and so naturally that often they do not even realize the thought processes involved. Color film or black and white? Fast film or fine-grained? Long lens or wide-angle? High viewpoint or low?

In all options, or alternates, we see how the principle of Tao expresses itself in the physical world. It works through the resolution of pairs of opposing characteristics, the Yin and the Yang: large and small, light and darkness, mass and airiness. Thus, Yin and Yang are at work continually in photography — in all its aspects and in all its processes. And, of course, Yin and Yang are also at work in the photographer.

The insights from these concepts promise a flowering of your overall awareness. They may unleash creative powers through a deepening of understanding. They will certainly reward the effort you make to integrate into them into your own work.

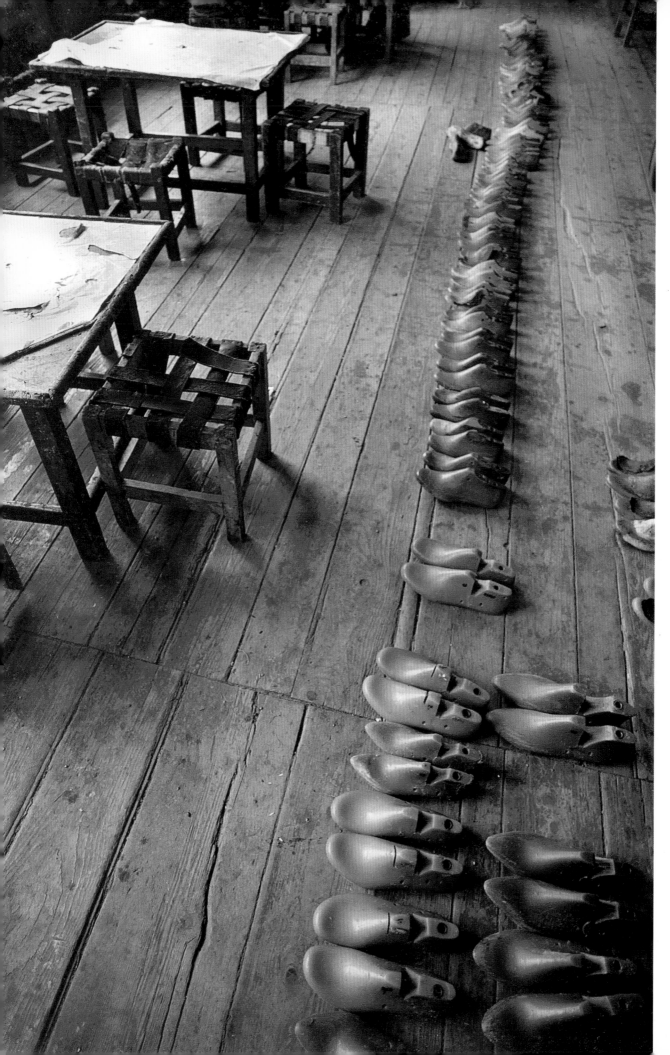

Left: One of the joys of photography is that you never know what will come at you from around the next corner. During a tour of a school in Romania struggling against poverty, sad and dismal classrooms offered little promise of evocative images — that is until we came across this workshop. A 20mm lens gave the wide-angle view needed to take in the whole line of wooden shoe lasts.

■Canon F-1n with 20mm lens; f/5.6 at ¹/₃₀ sec; ISO 400 film.

Welcome to the Way

In order to understand how Tao can help your photography it is not necessary to learn obscure tracts of Chinese philosophy. Indeed, Taoist teaching urges against the construction of theory. Traditional Taoist thinking is profoundly simple; and it likes to keep things that way. Nonetheless, in its profundity it is extremely resistant to being summarized. It is just really not possible to come up with an adequate single-sentence definition of Tao, unless it is something as unhelpful to the modern mind as "The Tao you can name is not the Tao" or that "The primary meaning of Tao is 'the Way' in a metaphysical rather than a literal sense." (In this book the word "Tao" and its literal translation "the Way" will be used interchangeably.)

Understanding how to think, see, work, and feel your photography within the scheme of Tao is both deeply satisfying and hugely fulfilling. More, Tao can enrich not only your photography and your experience of it, but it can also touch other parts of your life. Living and working in harmony with Tao can seem completely mysterious to the outside observer. Your abilities will seem uncanny, your balance and poise unattainable. But it is easy to work with Tao — you have simply to let it work with you.

Great photographers know how to be aware of everything around them, consciously and constantly seeing. The slightest movement in the bushes ahead could be the start of a chain of events. But most people did not even see the branches stir in the still air — to them it was invisible. Working in the studio, too, a practised photographer is always aware, even when clearing up — a passing juxtaposition of a half-eaten croissant and a mannequin's

"To follow the Way removes the need for fulfillment." Lao Tzu

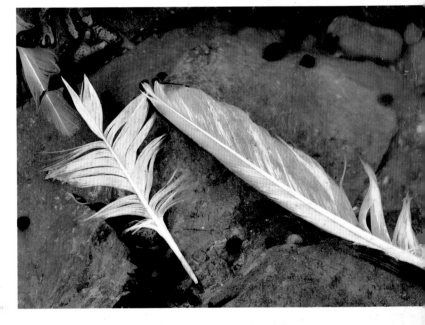

Above: Hundreds of people must have stepped across this rock pool, on the edge of a busy beach, but few of them can have noticed this little scene and stopped to enjoy its delicate beauty. A field camera mounted on a tripod was used to make this photograph. Many exposures had to be taken because the feathers would sway for several minutes even after the slightest breeze.
■Wista 45 Technical with 150mm lens; f/11 at 1 sec; ISO 125 film.

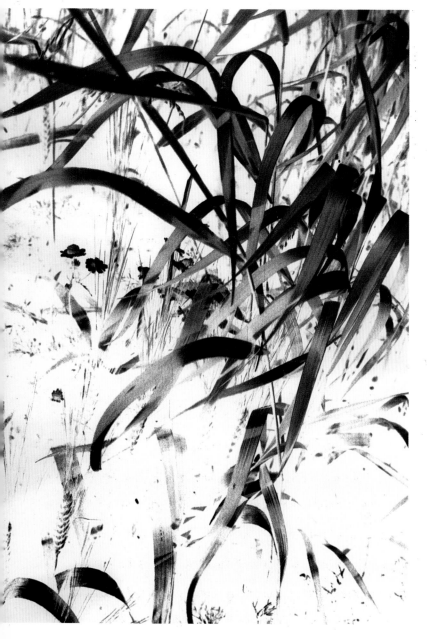

"The Way produces but does not possess; it fosters growth without ruling." Tao Te Ching

hand suddenly offers a visual pun, but only if the sensitive mind seizes on the momentary revelation of the deeper meaning that might be nestling among the mundane.

While photography is founded on the ability to see and record, it expresses itself only through a competence of technique. Yet over-attention to the technical aspects can cripple and inhibit creative photography. All photographers are familiar with the constant need for balancing and for compromise: a smaller lens aperture increases depth of field but lengthens exposure time; a faster film is more sensitive but less sharp. These balancing acts are the practical expression of the Way — one that lies between alternatives, each offering advantages and disadvantages. Therefore, to negotiate the Way with ease is to succeed in gently picking the advantages from the alternatives while leaving behind the contraries, continually answering questions such as "fast film or fine grain?," "depth of field or brief exposure?." And answering these questions, finding the balance, calls for a combination of attentive mind and technical knowledge.

As Ansel Adams exclaimed: "I believe in the most clarifying and revealing approach of mind, heart and craft." But heed this warning from Ernst Haas: "There is no formula. Only confirmations." And that is clearer now than ever: the era of the dominance of digital in photography has brought in new thinking, new techniques, and many new photographers. Yet — as we shall see — even the latest developments conform to — and confirm — the wisdom of the past.

Left: The negative-working process used to create rhis picture is like ink and wash — by drawing only dark areas you imply the light ones. Here, a black- and-white transparency has been printed, scanned, and the tones subtly manipulated. ■Canon F-1n with 28mm lens; f/5.6 at 1/30 sec; ISO 125 film.

Hybrid or inbred?

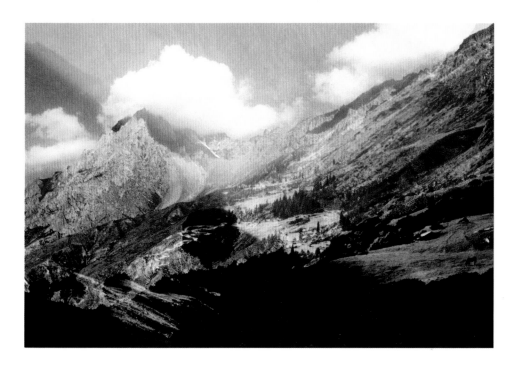

Left: Some of the richest, most intriguing photographic effects are, in fact, the simplest of all to achieve. This evocative, multilayered image is a double-exposure — first of a black-and-white print and then of a color print. The dark areas of the first exposure are able to receive additional image details, whereas the highlight areas are overexposed and cannot record any more information. A tapestry of unexpected tones results. ■Canon EOS-1n with 80–200mm lens @ 200mm; f/5.6 at ¹⁄₆₀ sec; ISO 100 film.

Photography is, of all the arts, the most closely bound up with technology. A photographer's awareness has, therefore, to be technically informed. Photographers are expected to be familiar with a wide range of photographic materials, and with digital embedding itself into photography the range of skills has expanded still further. There are many routes from the capture of the image to the final product, which can take many forms. All of these forms are characterized by a balance of advantages and disadvantages. And that balance wavers depending on your needs and purposes.

A strictly classical photography — fed on silver — is for many photographers the only true way. For them, any touch by digital technology is likely to engender aesthetic malaise. For others, a failure to embrace the digital world would leave them stranded. They are terrified of missing the boat of progress.

For the Tao photographer, the best way is both ways. A promiscuous exploitation of the strengths of any material, process, or technique available is the route to photographic heaven. This does not mean

> "As for the 'proper way': it is the beginning of disorder." Lao Tzu

you should use everything and pile on the effects; merely that you need not restrict yourself without good cause.

The options we enjoy today are more diverse than they have ever been in the history of photography. We are fortunate to be part of the first generation to enjoy such diversity and power of opportunity in this field, so why throw up barriers for no valid reason? More detailed discussions of materials and techniques are taken up in the chapter *Pathways of Sensitivity* (pp.37–55).

Exposing the vision

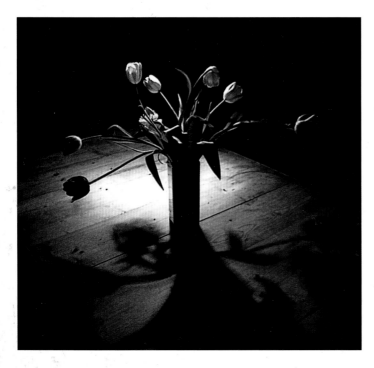

Film exposure in a conventional camera cannot discriminate between the needs of different parts of the image: a single combination of aperture and shutter settings, possibly with the addition of flash, must suffice to record an entire image of great tonal variety. Now, what is seldom appreciated is that the "proper" recording of an image depends far more on the combination of underexposed and overexposed areas than on the so-called "properly" exposed parts. That is simply because the majority of parts of most images are, in fact, not correctly exposed. To a large extent, therefore, camera exposure is about adjusting or balancing underexposure and overexposure to suit your vision of the image. That is a very different matter from attempting to find the "correct" exposure, which is the usual advice given.

Obtaining the exposure that best suits your subject is therefore more a matter of feeling and sensitivity – an approach following the Way – than of purely mechanical calculation. In practice, this can transform your thinking, which, in turn, alters the way you see the subject. By looking for the so-called "correct" exposure you tend to concentrate on those areas that are incorrectly exposed on the film – and so you end up fixating on failure. But if you work in terms that are in tune with the film's characteristics, instead of straining against the medium's limitations you will with increasing accuracy match subject and exposure. By working with the film, by being sensitive to its needs, you modulate the way you look and operate. Exposure measurement and how to control it are discussed more fully in the chapter *Expose for the Heart* (*pp.57–69*).

Above and opposite: Hardly any areas of these images are, technically speaking, "correctly" exposed. They rely almost entirely on the weight of black (underexposure) being balanced by small areas of highlight (overexposure) to define the subjects. Thus, different film exposures of these scenes would yield different balances – though none would be "right" or "wrong."

■**Above:** Rolleiflex SL66 with 80mm lens; f/4 at 1/15 sec; ISO 400 film.
■**Opposite:** Canon F-1n with 350mm lens; f/5.6 at 1/30 sec; ISO 40 film.

"I never calculate. That is why those who do, calculate so much less accurately than I." Pablo Picasso

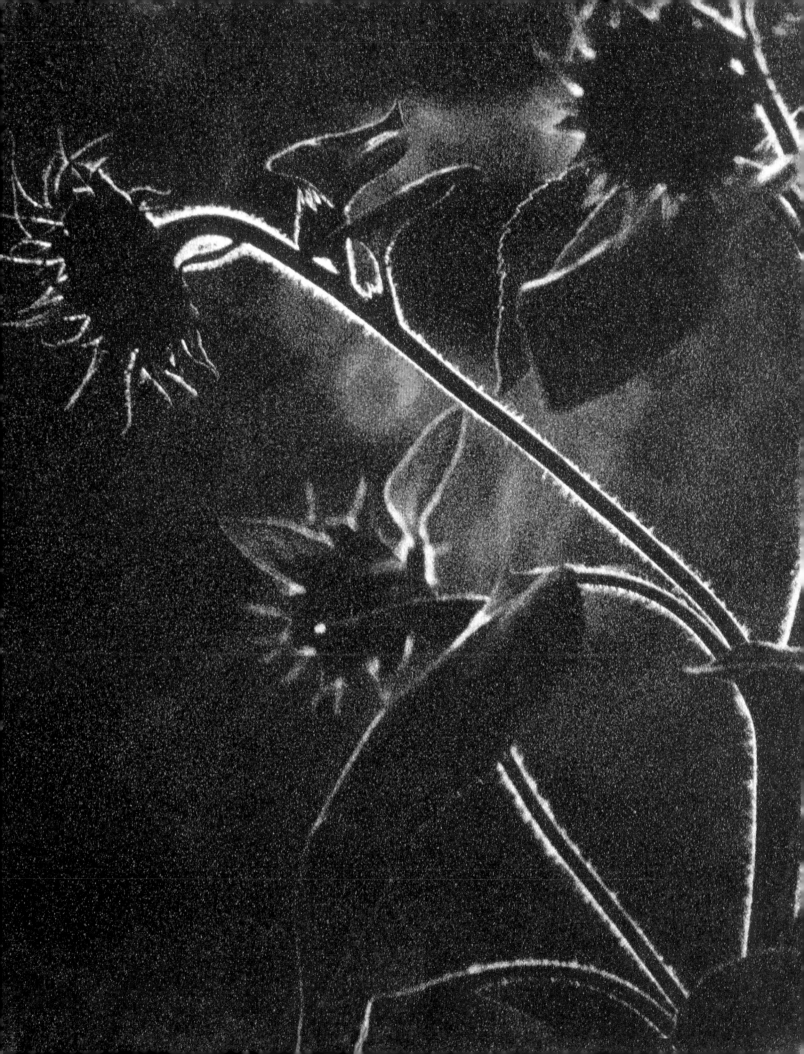

Tunnel of light

Photographers learn to see in two quite different ways, or contrasting modes if you like. One of these modes is unencumbered, free and effortless — in fact it is natural and instinctive — but it does have its limits. The other way of seeing is cumbersome, slow and inefficient. But, having said that, its limits are boundless. It can distinguish the details of the tiniest insect or it can reach far into the depths of stellar space.

To many photographers the gulf between these two modes is a source of constant frustration. They would share the wish and recognize the sentiment behind the words of the great fashion photographer Richard Avedon, who once sighed: "If I could do what I want with my eyes alone, I would be happy."

Photographers who are in tune with the Way of Tao would find themselves immune from the agony of frustration such as this. To the Tao of photography, both modes of vision are vital components of success. One is as important as the other, and each contributes its own strengths to the equation in order to bring about an effective partnership. Instead of straining at the perceived deficiencies of one mode or the other, Tao strives to ride with the virtues of each — one mode encompasses a scene broadly while the other focuses on the detail and the composition.

Right: In Namibia, a Himba woman adjusts her hair. This scene could have been made into any number of images, using focal lengths from wide-angle to telephoto. With each there is a new viewpoint, a different perspective. This image was made using a long lens at full aperture to restrict depth of field and minimize distractions. ■Canon F-1n with 300mm lens; f/2.8 at $\frac{1}{250}$ sec; ISO 100 film.

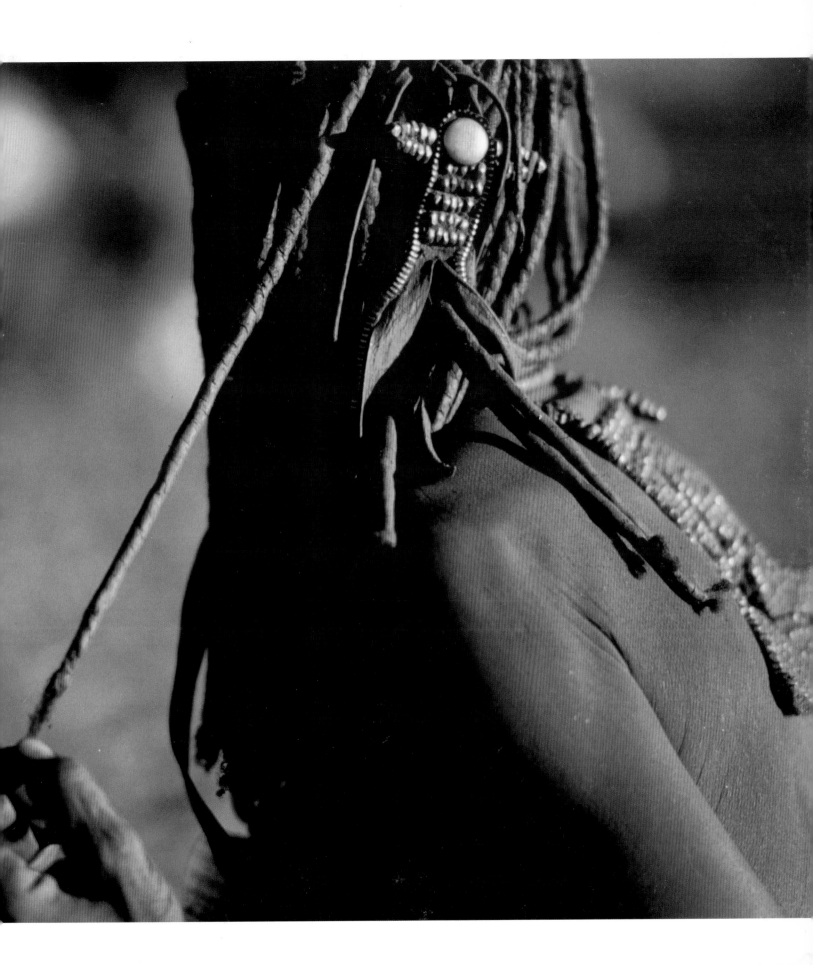

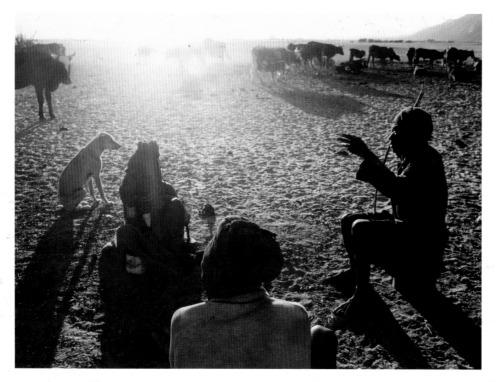

Left: It is easy to overlook the small fire in the middle of the camp of the Himba in Namibia — a hollow in the sand containing just a few glowing embers. Although small, it is sacred and watched over by the village elders, as it is considered the true center of the village around which all life revolves. At sunrise, people gather to discuss the day to come. Seeing is as much about being sensitive to other people as it is to recognizing the image.
■Canon F-1n with 20mm lens; f/5.6 at ¹/₁₂₅ sec; ISO 100 film.

The result of is that sensitive photographers learn to sense the image without having to lift the camera to their eye. Imagine the benefits to your work if, before you even take a picture, you are able to sense not only the point of view and focal length you want to use to achieve a specific effect but also the composition that will best give the image you are aiming for.

This type of "previsualization" is not by any means unique to the field of photography. Sculptors, for example, have to be able to "see" the shape they want to set free from a formless block of stone before they raise a chisel to it. How else would they know where to strike the first blow? Musicians, too, eventually learn to "hear" a note before they play or sing it. If they don't, you can be certain that it will be neither in tune nor tonally secure. Likewise, you can learn to "see" a picture before you take it: and when you acquire this ability, you will spend less time looking for photographs. They will discover themselves to you. You will then not need to seek; you will find.

In parallel with the confidence that comes from being able to previsualize a photograph, being aware of the Way provides you with a crucial balancing and steadying influence. And, as all sportspeople and martial artists know, a balanced position is the best from which to move forward.

With Tao, you will understand how to work with the strengths and weaknesses both of yourself and of your equipment. In fact, you will begin to question whether it is right, or even useful, to continue to classify properties into strength and weakness, plus and minus, negative and positive. You will learn to accept not only your tools, materials, and circumstances for what they are, you will also learn to accept yourself for what you are. You will begin to understand that at the core of every strength or technical advantage lies its weakness, and that in every weakness or disadvantage there is a strength waiting to reveal itself to you.

In *Finding the Way* (pp.70–91), the practice and development of the Tao manner of seeing is discussed in greater detail.

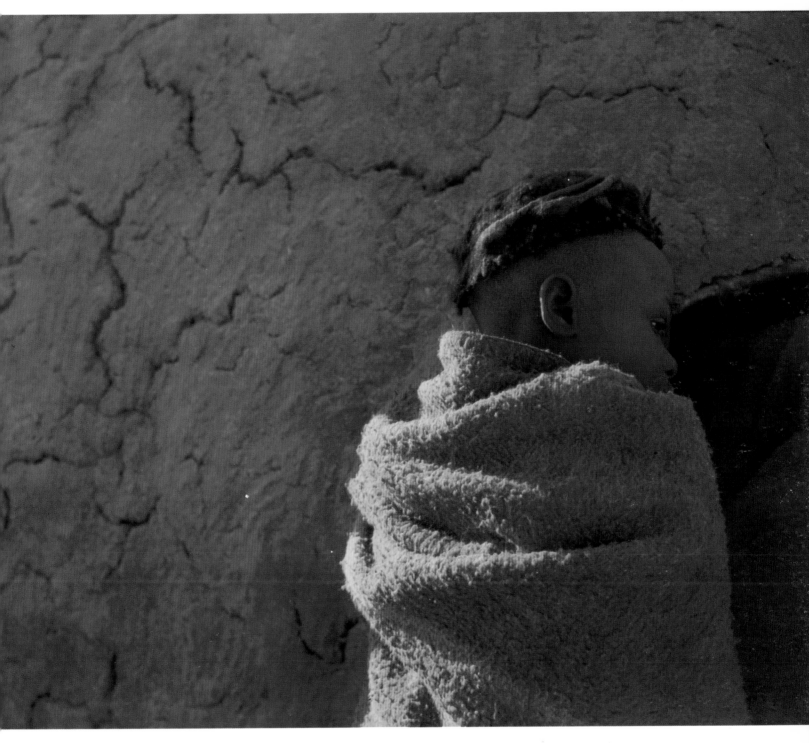

"I do not seek. I find." Pablo Picasso

Above: Even in the desert it becomes chilly at night. Here, a child wrapped in a blanket finds the first rays of the morning sun. This image redraws the visual experience, which lacked these deep shadows and rich colors. Yet the image manages to be truer to the actual experience.

■Canon F-1n with 300mm lens; f/2.8 at 1/125 sec; ISO 100 film.

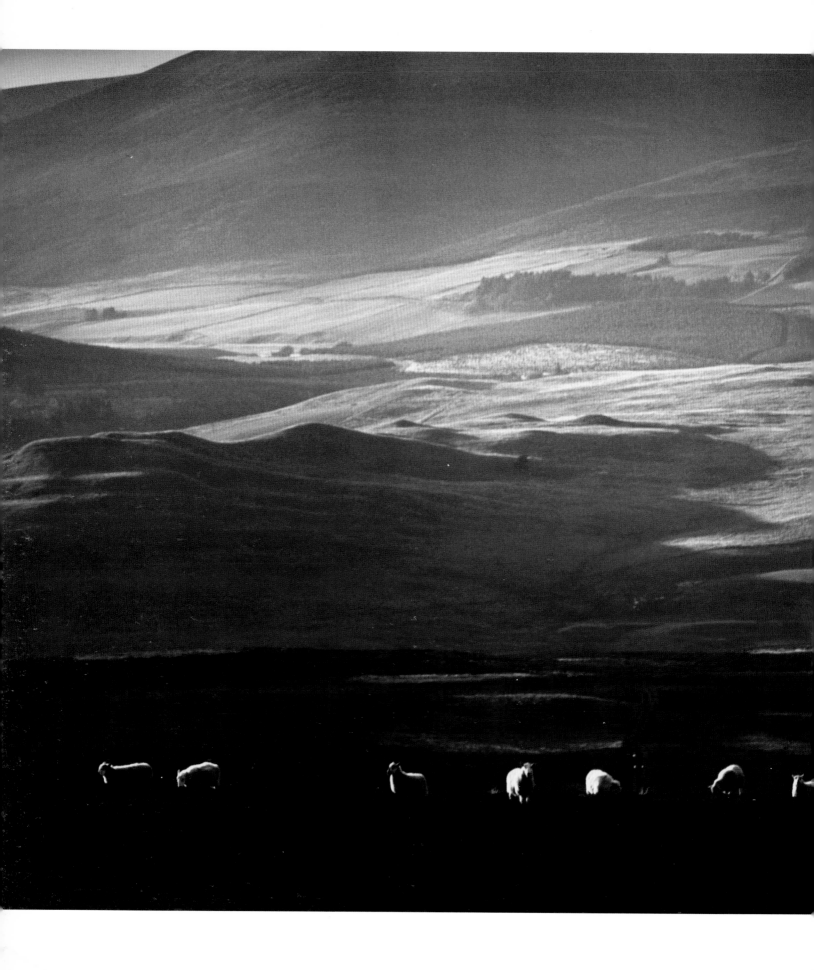

Netting the light

Of all the arts, photography is by far the most dependent on and, at the same time, the most attuned to advances in technology. Photography's invention had to await a sound understanding of chemistry while its development was, and continues to be, intimately linked with progress in optics, precision tooling, and the imaging sciences. This might seem to disqualify photography from being illuminated by a philosophy that is about two and a half millennia old. But if Taoist concepts are able to contribute their insights to debates about quantum physics, they can surely teach us a thing or two about photography — and not only its emotional or spiritual dimensions, but even its most practical aspects, such as the selection of an appropriate photographic outfit.

One approach to photographic problems is to overcome them by bringing to bear the combined firepower of extreme focal length and large, light-grabbing apertures plus motor-driven camera bodies with powerful flashguns — it is positive, muscular, and direct in attitude. Tao would say this is using Yang qualities for solving problems. The alternative is a modest outfit, with an emphasis on compactness, maneuvrability, and inconspicuous methods. This relies on the softer, less technocratic skills of the photographer who is in tune with the not-so-glamorous examples of equipment. Such an approach — low on confrontation — can be said to be Yin in character. It is clear that a balance between the Yang and the Yin will be most practical as well as most fruitful.

A little goes the furthest

The opposing approaches concerning which camera equipment is best to use amount to a stand-off between those who believe that top-quality and specifically appropriate equipment is essential and those who believe all that matters is the mind and artistry of the photographer. The Tao photographer can float above such debate. The best choice of equipment is in fact no choice at all. This is because it is not you who makes the choice: it is far easier to allow the subject to guide you.

Many of the great photographers use the bare minimum of equipment – and it can get no simpler than one camera with one lens and no exposure meter. And because it is so lightweight, such an outfit can guarantee rapid responses to chance events. A colleague once walked down the street with Henri Cartier-Bresson and reported how the photographer constantly raised his camera to his eye and then lowered it again, but he did this so quickly that the movement was hardly noticed by anybody.

With such a refined outfit, you do not have to evaluate an opportunity in terms of whether a wide-angle would be better than a distant perspective and, if so, exactly which focal length would be best. Having just the bare necessities makes you more agile in body and mind. And there is more. The very limitations of the equipment force you to work harder. The fewer visual tricks you can rely on as a result of using extreme focal-length effects, the cleverer you have to be about the basics of composition and timing.

Of course, a camera outfit has to match need. A wildlife photographer, for example, may rely on a motor-driven 35mm SLR and a 400mm f/2.8 telephoto lens. An architectural photographer will be happiest with a wide-angle lens on a field camera.

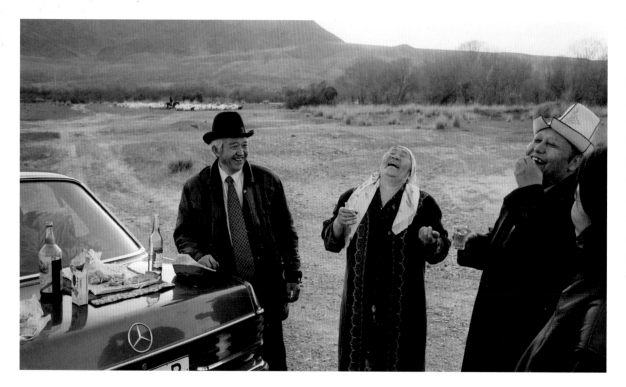

Left: You can shoot an impromptu celebration such as this, near Issyk-Kul in Kyrgyzstan, with a camera costing a fortune or with the cheapest of snapshot models. The difference in price buys you reliable performance and high optical quality. And a well-made camera does encourage you to work at your photography.
■Leica M6 with 35mm lens; f/4 at ¹⁄₆₀ sec; ISO 400 film.

For landscapes, many workers find that the Hasselblad SWC with its fixed 38mm super-wide-angle lens is a most versatile all-round piece of equipment to use.

A favorite location outfit is a 35mm-format camera fitted with a standard or moderately wide-angle lens. The Nikon FM2, Canon F-1n, and Leica R6 cameras are all highly regarded. But the most unobtrusive of all the 35mm cameras are the rangefinder types, of which the Leica M6 is the finest example. Combined with a 50mm or 35mm f/2 lens, it gives enough photographic firepower for an entire career. The Konica Hexar RF and Contax G2 are less costly alternatives to the Leica.

With an SLR (single-lens reflex) camera, a good choice of lens is a fast macro with a focal length of 50–60mm. It will have a maximum aperture of about f/2.8 and be able to focus to half or full life-size. Such lenses are extremely sharp and are limited only in their low-light abilities. For working in the widest range of lighting conditions, you might prefer a faster lens, such as f/1.4.

The alternative to a fixed-focal-length lens is a zoom, such as something around 28–80mm. The Canon 28–70mm f/2.8 and Leica 35–70mm f/2.8 are well able to approach the optical quality of non-zoom lenses. Zooms with very wide ranges, such as 28–200mm or 35–350mm, are tempting, but, with a very few, premium-priced exceptions, generally deliver only mediocre performance.

For medium-format work, you can go a long way with a standard 80mm lens, especially if you are using the versatile 6 x 6cm (2¼ x 2¼in) square-format option. The classic TLR (twin-lens reflex) Rolleiflex with an 80mm f/2.8 lens is still hard to beat, but Hassselblad, Bronica, and Mamiya cameras fitted with standard lenses also all deliver exquisite image quality with minimum fuss.

"I've got plenty of nothing; nothing's plenty for me. Got my song . . . got Heaven the whole day long." from Porgy and Bess

Above: When I am shooting mostly in color, I use a Leica M6 with a 35mm f/2 lens for black-and-white snapshots, such as those above and opposite, which would not work ideally in color. In the image here, black and white is the best way to handle the scene's high light levels and contrastiness. ▪Leica M6 with 35mm lens; f/8 at ¹/₂₅₀ sec; ISO 400 film.

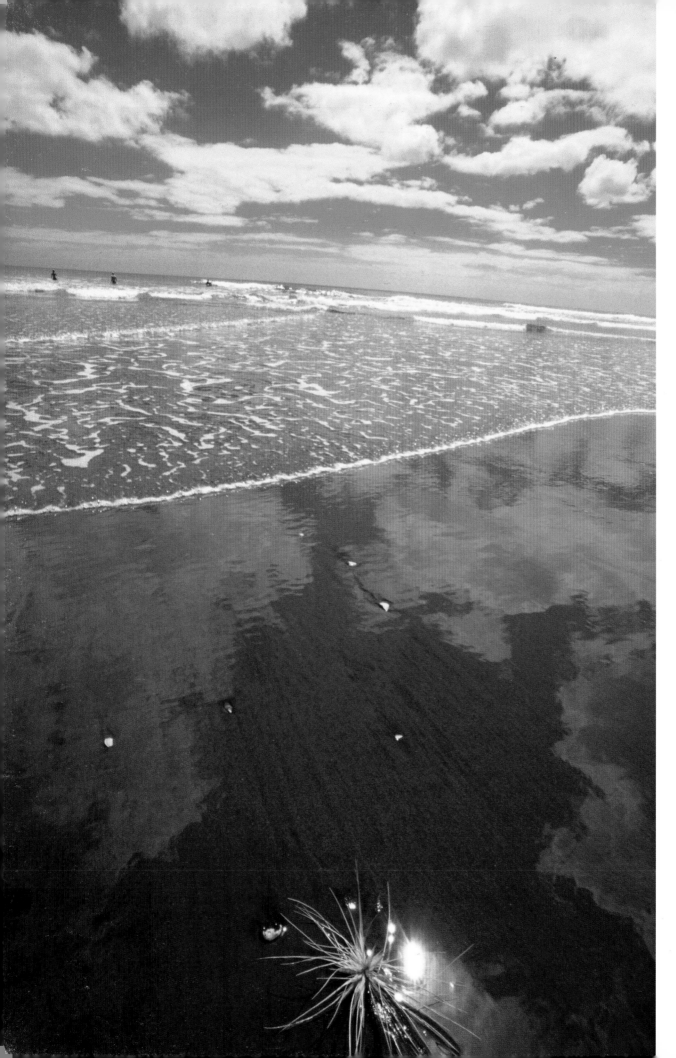

Left: Nothing could conjure precisely the vast playground-like feeling of this beach in New Zealand. But a photographer has to try, not only by using an ultra-wide-angle view, but also by using the lines of the gentle waves and exploiting the details in the foreground to help evoke a sense of space.

■Canon EOS-1n with 17—35mm lens @ 17mm; f/7 at $1/_{250}$ sec; ISO 100 film.

A portal to imaging worlds

The camera lens is the portal through which your subject passes to enter the world of photography. For it is the lens that draws the image for you, defining image scale and perspective in conjunction with camera position – and from the lens flow many of the subtler image characteristics, such as richness of color and smoothness of tone. To the experienced photographer, a choice of lens revolves not only around optical specifications of focal length and maximum aperture, but also the precise qualities of the image itself.

Your choice of lens has to steer a path between many conflicting calls: high quality means a high price, while a large aperture means a heavier and costlier lens; a long focal length for high magnification means a larger, longer lens and more problems with camera shake. And while an ultra-wide-angle lens can be effective, it is also difficult to use well. All photographers spend much of their life steering between what is possible – budgets permitting – and what is desirable.

Interestingly, the design of an optical system also presents a perfect illustration of the struggle to attain the Middle Way. Every aspect of a lens's final specification demonstrates that a balance of conflicting needs has been reached. We ask for the highest-resolution lens, but are we prepared to sacrifice some contrast? We want high-speed lenses, but will we tolerate the necessarily higher levels of aberrations? In the detail, too, there is much devilry: to correct for one defect you usually have to sacrifice the correction of some other optical aberration.

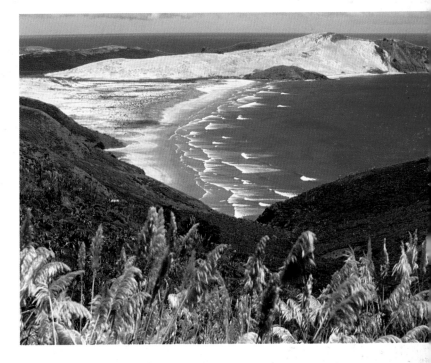

Above: If you do not want to be weighed down with heavy equipment when you go on long walks, today's zoom lenses can offer excellent image quality in a compact form.
■ Canon EOS–1in with 80–200mm lens @ 200mm; f/8 at $\frac{1}{250}$ sec; ISO 100 film.

"Knowledge of the means to express our emotion is essential – and is acquired only after very long experience." Paul Cézanne

The digital opposition

The current debate among photographers, concerning the merits of digital cameras compared with those of film-based cameras, often comes down to opposition between what is seen as digital's forces of brute technology in contrast to the cozy values of the touchy-feely craft-based skills of the traditional darkroom. Another strand of the debate also encompasses comparisons between the quality of film-based images and the usually inferior images produced by digital cameras. In reality, the truth of the matter can be more usefully seen as a balance between the individual merits of each technology. Understood in this fashion, your delightful and only task is to match means to aims.

On any occasion or for whatever reason you need rapid results, or when you need to distribute images easily, or should you need to be free from the paraphernalia of the darkroom, digital photography is a far better choice than conventional, silver-based technology.

"The Wise act in the context of the totality: the totality is what works – such is efficiency; efficiency is attainment." Chuang Tzu

You can think of digital cameras as being a little like the fast-food of photography. The motivation underlying their invention was convenience. In this regard, digital photography shares the same roots as photography, which was itself invented to avoid the many inconveniences of drawing with paints, pencils, or sticks of

charcoal. If speed and mobility are typically Yang qualities, then the Yin qualities of the digital image are the necessarily balancing factors: simplicity – the relinquishing of unnecessary information (such as lower-quality images, for example) – and fragility, in both the equipment and the utilization of the images.

As another example of the balancing of attributes, consider the dimensions of the image detector (CCD) found on the digital camera. Although its diminutive size enables very compact cameras to be produced, its size also makes it difficult to provide ultra-wide-angle views. This is because extremely short-focal-length lenses are then needed. Only very expensive, large-sized sensors permit ultra-wide-angle image capture on a digital camera.

Once the photographic image enters the digital domain – whether it was silver-based or digital in the first place makes no difference at all – the powerful Yang qualities of the computer can take over from the Yin qualities of the image, which can be summarized as delicacy of detail, fragility, and uniqueness of content. The computer can now apply its tremendous computational powers to the transformation of any image that is scanned into its circuits.

 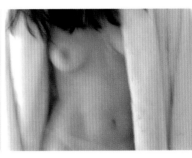

Bear in mind that the changes the computer makes possible are not confined just to the content of the image. Perhaps of even greater importance is the fact that the digital image can be processed easily to be used in many different forms and in many different media. It can, for example, be published on the Internet, copied on to a CD-ROM, imprinted on to the pages of a traditional book, or output on to canvas as a personal gift to a friend or to become merely the first stage in a completely different art form.

From the very earliest days of photography the search was on to create copies quickly and easily so that as many people as possible could see an image. The application of the printing press was a tremendous boon to photography, leading to the great days of photojournalism from the middle decades of the twentieth century. But the image clung stubbornly to the page, to the piece of paper. Now, in the digital age, a single image can be in a thousand

Above: Digital cameras can be the perfect device for many informal shooting situations. You can make dozens of shots without inhibition and simply delete unwanted ones at your leisure — as you are not using film or processing, nothing is wasted. You are limited only by the memory available for your camera — and at today's prices for memory, the whole process can work out far cheaper than film in the long run.
■ Kodak DCS315 with 24–50mm lens @ 30mm; f/3.5 at 1/30 sec; "ISO 100" digital speed.

Above: This statue of a bodhisattva carved out of a cliff face in China was taken on an expedition that lasted five months.
■Leica R-6 with 70-210mm lens; @ 150mm; f/5.6; ISO 400 film.

Opposite: The dark sands at Durdle Door in England contrast with the chalky white cliffs. This image had lain dormant in a file for many years, and was revived only when digital duotones promised to breathe new life into it. The image has been dodged digitally to improve tonal balance, then given a blue ink in addition to black.
■Canon F-1n with 135mm lens; f/8 @ ¹/₃₀ sec; ISO 25 film.

different places at the same time, in locations all over the world. And as well as simply being passively viewed, that same image can just as easily be downloaded into any number of computers to be manipulated, sized up for traditional printing, or redistributed in electronic form anywhere in the world.

Now, turning our attention to the opposition, the conventional photographic print is indisputably the lovelier thing to hold in your hands, to feel, to look at. In addition, you can tuck a small-sized print conveniently into your wallet and reach for it whenever you want a reminder of a particular object, scene, or loved one. When you want to show holiday snapshots to some unfortunate dinner guests, you need only reach for an album of prints. And if a guest, accidentally or otherwise, should pour wine over a print, or should it lie crumpled and forgotten in a shirt pocket for months, or even if the dog should run off with it in its mouth, the picture will still be recognizable once you have dabbed it dry or pressed it flat. Compared to these standards of robustness and convenience, digital images must retire gracefully from the fray — they cannot hope to compete with the print. The Yang of robustness and individuality wins over the ephemeral nature of the Yin and the digital image's ability to be formed into endless variations of itself.

Guided by Tao, a photographer stands back to gaze at the totality of these processes; sees the balancing forces of Yin and Yang at work, and makes a choice. Seeking a route that is smooth (minimizing quality-loss while maximizing facility) and which delivers the desired results (providing satisfaction both in its subjective as well as in its objective qualities) is the goal. Gone, then, are the boundaries between digital and non-digital, right or wrong. At different times and for different tasks, all techniques work — but some work better than others.

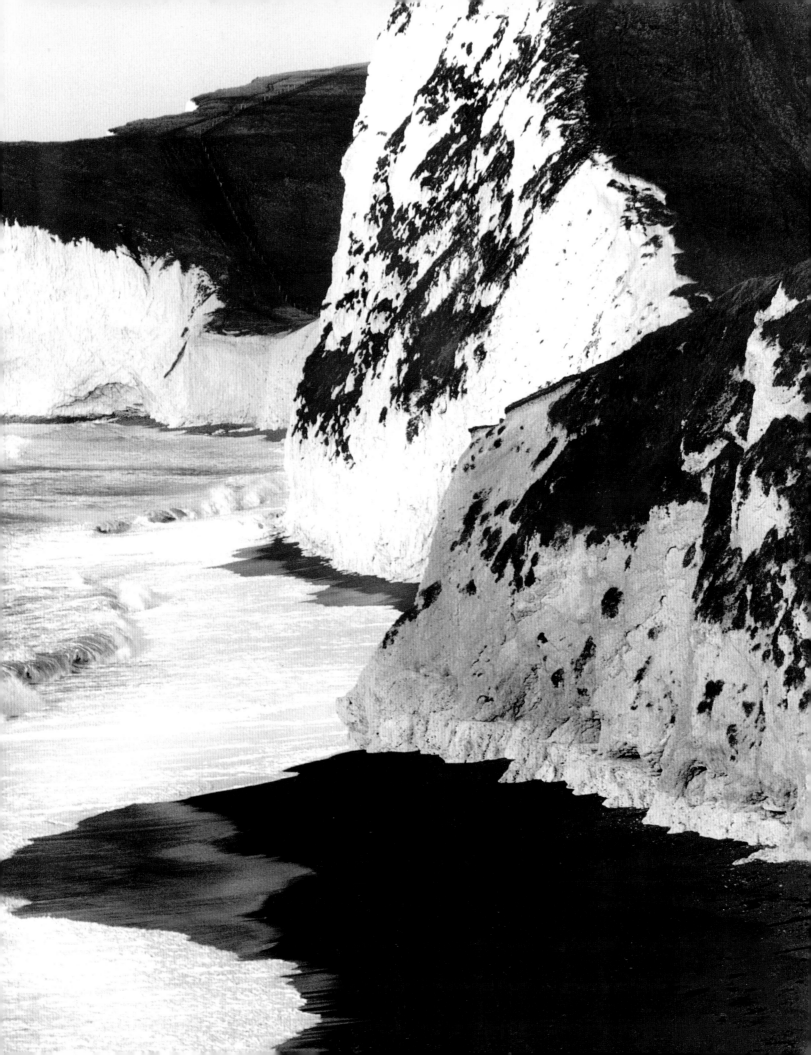

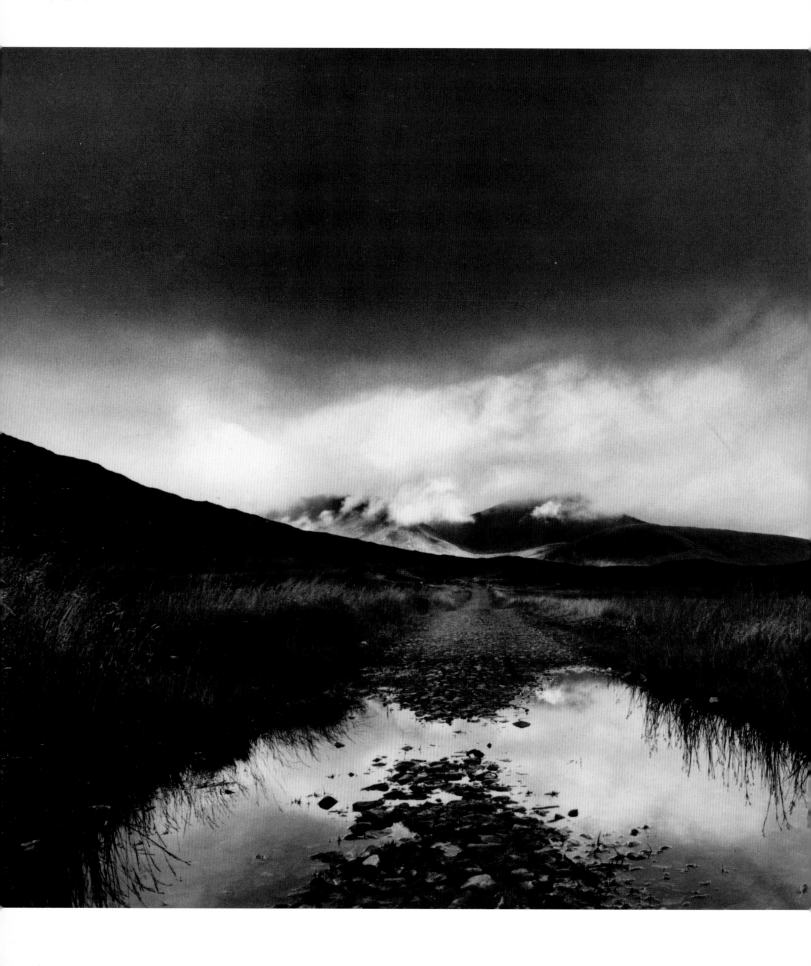

Pathways of sensitivity

Photography is not a stage-by-stage production process of the type you might find on a vehicle assembly line. Not only are the end products of the endeavor many and varied — the fine-art print, for example, or the image for a web site, a reproduction to appear in a newspaper or magazine, an in-house newsletter, a folio in a monograph, and so on — the routes to those destinations are myriad and often fascinating. You can approach the choice with a mind that seeks the one perfect pathway . . . or you may not.

The Tao slant on this process says that when you look for a route through the pathways of photography, to seek the "proper way" is to ask for trouble and tears. To believe in a perfect solution is the start of confusion.

As in the choice of photographic equipment, the decisions needed to negotiate the pathway from image capture to its final end-use are legion, interrelated, and touch on complicated issues. Not only are they about balancing the pros and cons of one material or process against another, the subtleties of individual taste will demand a positive role.

The route map for the photographic process is produced by acquiring knowledge of the many processes and techniques available. This acquisition is often governed by a search for the "proper way." But the more open your mind, the greater will be the completeness of the map. If you demand a "proper way," the map will show only one thing: the route to buried treasure. And buried it is likely to remain.

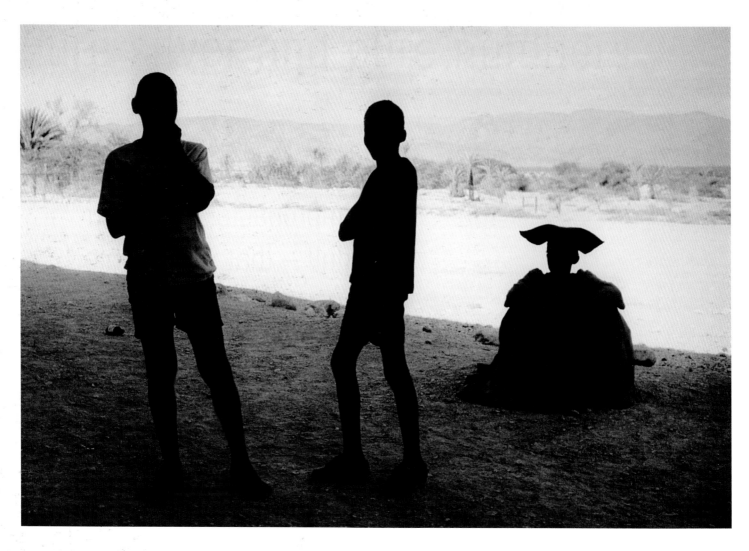

In exchange for the steadfast Yang properties of permanence and longevity you find in the silver-based route, the digital path stresses the highly Yin character of openness and versatility – but also inherent impermanence. Digital cameras make an image almost immediately available, and once the file of an image is on a network – such as the World Wide Web – it can be simultaneously accessed by any number of people. And a digital file is capable of infinite transformations, carried out with an ease and convenience that silver-based techniques could never hope to match. But a tiny error in reading the image data from the digital camera – perhaps caused by such simple a thing as a speck of dust or a break in a tiny wire – brutally plunges this photographic utopia in darkness.

Above: There always seems to be a little crowd gathered around gas stations in Namibia. It would have been nice to be able to reward the friendly interest by showing these people what had been photographed. For this, a digital camera with an LCD screen is ideal – as soon as you capture the image, you can play it back. It is a friendly gesture and small thanks for any cooperation. ∎Leica M6 with 35mm lens; f/5.6 at $1/250$ sec; ISO 400 film.

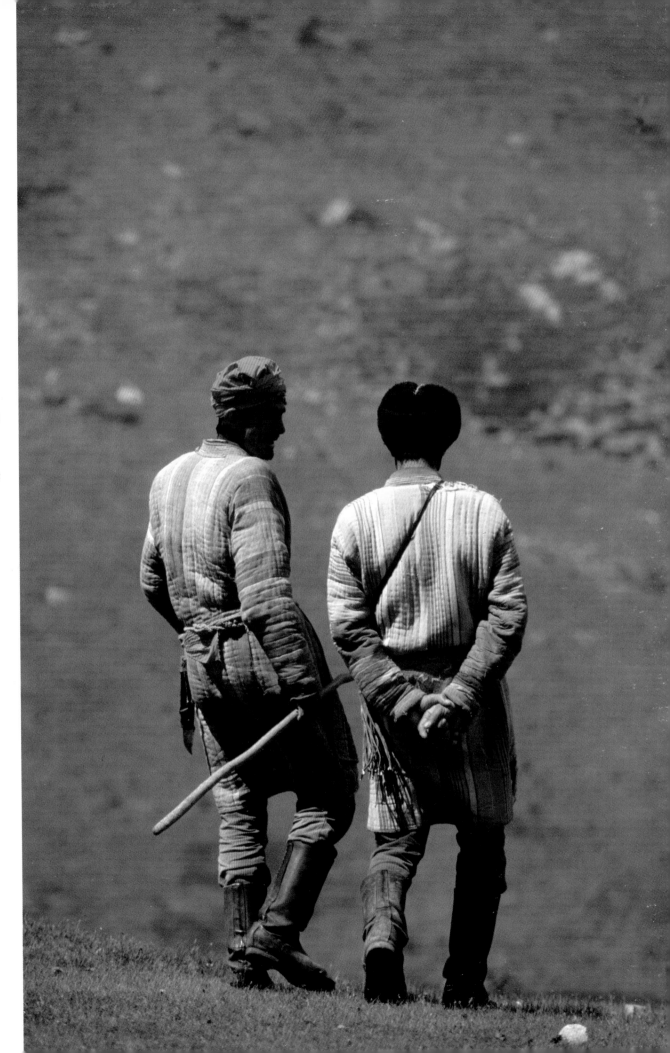

Right: At the snow line in the mountains of northern Tajikistan, two shepherds discuss their flocks. An earlier shot, taken with a 20mm lens, showed their mountainous surroundings, but as they walked away (having made their greetings) I followed them with an 80—200mm zoom, setting longer and longer focal lengths and waiting for an image to present itself. In these conditions, there is no doubt that the most reliable, cost-effective equipment is film-based and not digital.

■Canon EOS-1n with 80—200mm lens @ 200mm; f/4 at ¹/₁₂₅ sec; ISO 100 film.

Black and white supreme

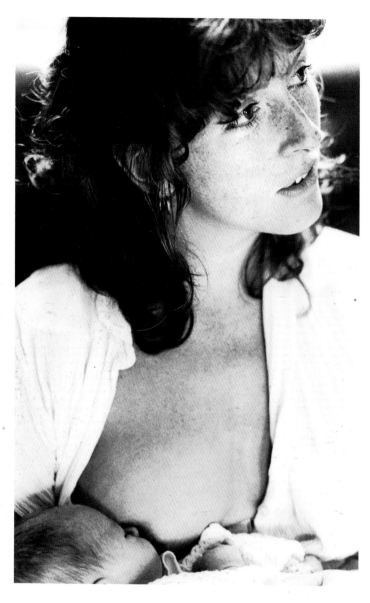

Above: Beauty and simplicity do not have to be propped up or enhanced by the use of special effects or the introduction of color. This scene in a hospital maternity ward says all there is to say without the need for artifice. ■Olympus OM-2n with 85mm lens; f/2.8 at $\frac{1}{125}$ sec; ISO 400 film.

A little experience of digital image manipulation quickly proves one thing: the more power there is to transform an image, the easier it is to make a complete mess of it. The purity and simplicity of black and white comes as a relief, like a meditative haven after the bustle and noise of digital. If the strength of black and white is its ability to simplify a riot of colors into a sedate procession of grays, its weakness lies in precisely the same region. That process of simplification is neither perfect nor reliable.

Most black-and-white films are so-called "panchromatic"; in other words, they record all the visible wavelengths of "white" light. But not all wavelengths are equal – for example, most films are overly sensitive to blues and so these are recorded as being too light, or overexposed. In addition, films don't know that people place a higher psychological value on some colors than on others: greens are much less attention-grabbing to the eye than reds, for example, but to black-and-white film even vibrant reds are reproduced as the same midtone gray as the dullest of dark greens.

The odd thing about black-and-white photography is that "black" for photographers is seldom black at all, nor is white very white. Black is usually defined in terms of light absorption, but actually we never judge anything on the basis of adsorbed light. We can see anything only by the light that is reflected. The fact is that there will always be some color in a photographic black. A critical look at whites in a print, or even in a color transparency, will deliver much the same view – whites are not perfect, they are not uncolored. The net result of this is that the tonal range recorded by black-and-white films or prints is rather limited.

Much of the art of black-and-white printing is determining how to make the most of the inherently limited tonal range of the print material. The standard tactic is to suggest a wider tonal range than really exists: we increase the contrast of the psychologically important midtone range in order to suggest that when you look into the shadows they will appear really deep and the highlights will look really bright.

Ironically, photographers have never been entirely satisfied with this attempt at a visual sleight of hand – which is why all photographers occasionally consider toning their prints. Toning transforms the silvery pseudo-black into anything from blue through coffee browns to rusty reds. It is as if to say: "If it's not black, why pretend? Let's make it blue . . . or brown or red."

With silver-based processes, toning replaces the particulate silver metal in the image with other metals or metallic compounds. These disperse light more selectively than does the silver, and it is this that creates the colorful effects. Gold toning, for example, absorbs blue and green light but disperses yellow and red, giving characteristic reddish-brown hues. At the same time, toning also reduces the tonal range of the print. It must do so, since blacks are toned into a deep color, which naturally reduces the maximum density. This means that the difference between the brightest area and the darkest is less than before the toning; therefore, the tonal range is compressed. Nonetheless, the advantage of a colored image often outweighs the tonal losses. Once again, we find ourselves turning to a solution that brings together the best of both worlds – color in the black-and-white image.

> "Black and white are the colors of photography. To me they symbolize the alternatives of hope and despair to which mankind is forever subjected." Robert Frank

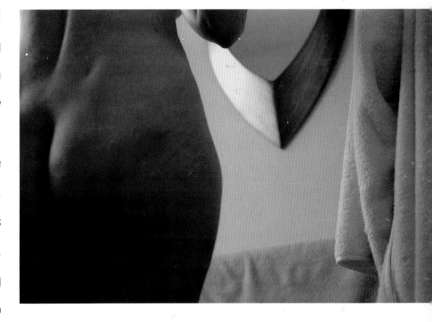

Above: Toning an image lengthens the apparent range of tones, as well as signaling, by the hue you select to use, the emotional content of the image. This is an informal snap that has been given lift and life by digital "toning." ■Mamiya 645 with 75mm lens; f/2.8 at $\frac{1}{30}$ sec; ISO 400 film.

Dueling partners

At this point, silver-based photography and digital processes can come together to create a highly productive partnership. The best way to introduce color into the black-and-white image is to use a duotone. In the duotone process, two different inks are used: one ink is the normal black, the second is a colored ink that can vary in

> "I do not believe that something reports itself in a photograph. It is redrawn." Richard Avedon

intensity from very light to very dark. The most often used second-color ink is a warm-toned black or brown. The result is to enrich the whole visual experience of the printed product. The subtle separation of hue in the low-to-lower midtone areas of an image has the effect of conjuring up the appearance of a wider range of tones than are actually present.

Of all the digital techniques available to photographers, perhaps the most simply beautiful and rewarding involve the creation of duotone prints. Bear in mind that the effect of using two inks is simulated in the output device, or printer, by a combination of four or more inks. It may seem that using, say, six inks simply to improve a black-and-white image is a little like taking an ax to cut a matchstick. But it is part of the paradoxical nature of imaging that we do need tremendous amounts of computing power in order to bring about the subtlest improvements in the raw, silver-based image. First the black-and-

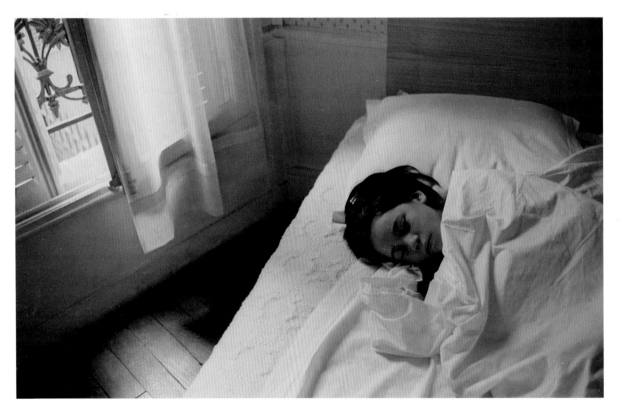

Left: It is easy to confine pictures of one's children to happy, party-atmosphere snapshots. But the quiet, vulnerable moments, with a little mystery (the open window, the moving curtains) are emotionally far richer, far more memorable. After digitizing, the image was given the electronic duotone treatment.
■Leica M6 with 35mm lens; f/8 at ⅟₆₀ sec; ISO 400 film.

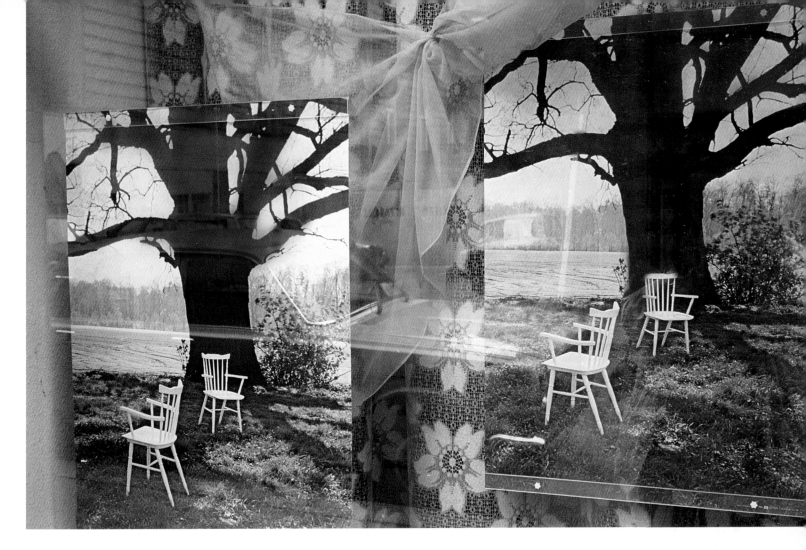

white original must be scanned, then manipulated in the computer, and finally output once more.

Fortunately for most people, those of us who just want the means to produce a specific effect, it is possible to leave the complicated color calculations to the image-manipulation software. In such well-known software programs as Adobe Photoshop, duotone (also tritone and quadtone, which use three or four inks, respectively) creation can be done with great flexibility and fluidity. The Tao photographer simply takes up the tools and works with them. Complicated techniques for simple effects, simple tools for complicated effects — all are of no importance. The question in essence is: Does the image have emotion or not? Certainly, it is without doubt that a duotone image offers more reward to the eye than a plain black-and-white print.

Above: An elaborate tritone was created for this image, with different tones matched to a range of densities to give a subtle range of colors. This "colorized" image without distracting from its already complicated and intriguing content — a shop window in Prague, Czech Republic, carrying two identical posters. It was taken with a wide-angle lens and my reflection, which appeared in the glass, was removed digitally before the image was printed.
■Contax RTS with 35mm lens; f/4 at 1/60 sec; ISO 400 film.

Grain and gain

There has always been a tension between a film's sensitivity to light and the graininess of the resulting image. And even in the digital era, this reciprocity of sensitivity to graininess still holds. The opposition is familiar: we need to increase film speed, but higher speeds need larger silver grains and this, in turn, means less sharpness, lower resolution, and less smooth tonal variation. In the digital arena, a greater sensitivity of the photodetectors or amplification ("gain") of the detector signals gives not only a larger signal but also more electronic noise. This is seen as random pixels whose values are not related to their immediate neighbors.

The Yang property of high speed — and greater light-sensitivity — is, therefore, continually at tension with the Yin of tonal subtlety and fineness of detail. Great effort has been exercised on easing

"... the very best pictures adapt themselves to many changes in meaning." John Swarkowski

this tension by, for example, growing silver crystals in forms that are not usually encountered in nature in order to improve their light-gathering efficiency or by adding chemicals into crystal to broaden their sensitivity. In digital photography, engineers are trying different configurations of photodetector to improve the ratio between sensitivity and noise or trying to invent new types of detector.

Grain or noise reduces not only the amount of detail that can be recorded, but also the smoothness of tonal transitions. In addition, random flecks of color mixed in an area of a particular hue necessarily create a ceiling on the saturation of color that can be recorded. In short, any gains made in the speed of a film or the speed of a sensor can be said to be won at a high cost — something that is characteristic of Yin properties. Subtlety and fineness are not robust elements; they can be easily eroded by meeting a call for the Yang qualities of a speedy response and convenience. But then, a Tao photographer would accept the shortcomings of the materials in the same way that he might love the faults of a friend. The toned-down colors and the lack of sharpness — what of that? They are but foundations on which to create art.

Equally, a photographer might look at the lumpily grained results from fast film and say: "What great grain! I could use that." Grain could give texture to a featureless sky or it could complement the atmosphere of mystery and darkness.

Indeed, the fact is that without any grain at all, images would all look alike: sleek and smooth, like polished marble. Grain defines the warp and weft of an image's make-up. Indeed, different processing regimes for black and white are available to produce different qualities of grain. Some high-speed developers, such as Rodinal, working at high-dilution can be counted on to produce cleanly defined, particularly small, grain.

Classic formulations such as PQ (phenidone-hydroquinone)-type developers (ID-11 or D-76, for example) will produce fine grain, but their negatives are not as "sharp" as those from Rodinal-type developers. And, of course, underexposing a film followed by extra development (in other words, push-processing a film) will increase

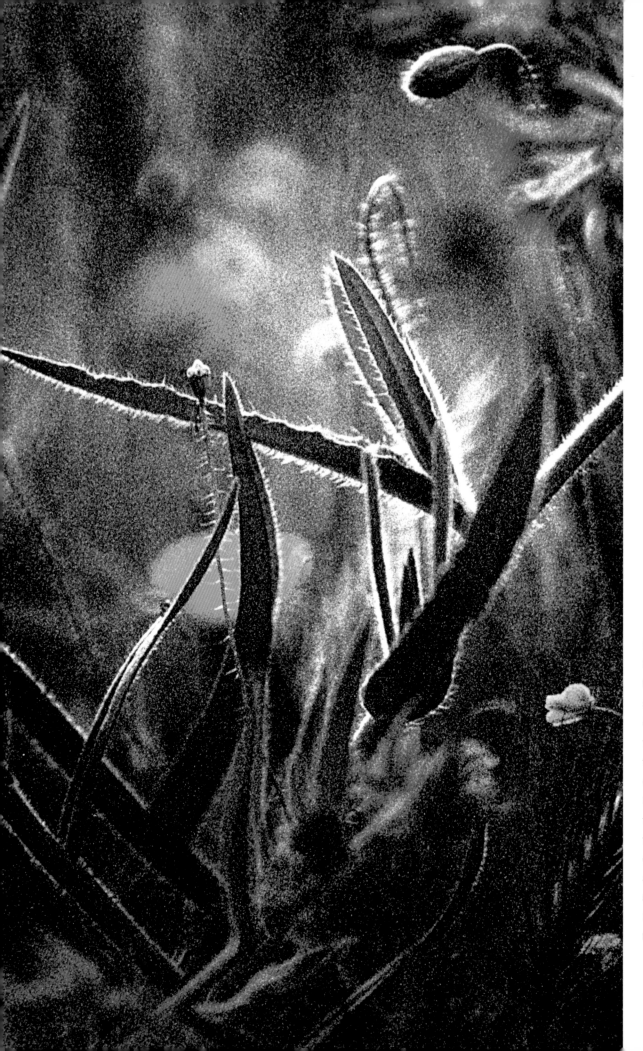

Left: The graininess of Polachrome film is uniquely high, yet detail remains sharp. It thus delivers a distinctly painterly effect without the need to resort to image manipulation. After exposing this subject on Polachrome, I duplicated the image on normal color transparency film, which greatly increased contrast and color saturation.
■Canon F-1n with 350mm lens; f/5.6 at $\frac{1}{30}$ sec; ISO 400 film.

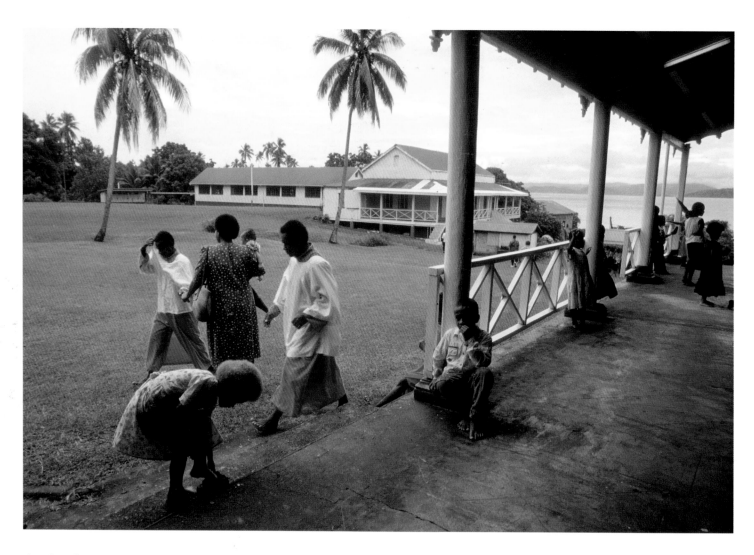

the size of grain, though this will be at the expense of an increase in contrast leading to heavy, dense highlight areas.

Modern ultra-fast films – such as Kodak T-Max 3200 and Ilford Delta 3200 – are actually so cleverly designed that their grain can appear be smaller and more refined than that of medium-speed films of the past. As a result, if you want really grainy results, you now have to work hard to achieve it. If you use an old-style ISO-400 emulsion, such as Kodak Tri-X, and push-process it, you can get far grainier results than using today's ultra-fast films. An alternative is to simulate the appearance of grain using digital techniques by, for example, adding digital noise using image-manipulation software. You can then control the exact degree of graininess you want.

Above: A hurriedly snatched shot led to an underexposed transparency. When it came to scanning, the only way to retrieve the situation was to increase color saturation and distort some of the tonal values. Whether the colors are acceptable or not, they are only distantly related to those of the real scene. ∎Canon EOS-1n with 17–35mm lens @ 24mm; f/5.6 at $\frac{1}{200}$ sec; ISO 100 film.

Palatable colors

The very first painters rendered images in colors that, one must imagine, matched those of the painter's experience. And we know that it was only moments after the shock of seeing their first photograph had subsided that viewers started complaining about the lack of color in the image. Modern color photography results from a fusion of very clever technology and an understanding of human psychology. It is poetic that modern color photography was invented by two classical musicians who, as one delightful story tells, hummed a violin sonata to each other in order to time a chemical reaction. But it is still true today that the creation of a color film is the result of human preferences winning over technical hurdles: as a result, each color film has its own specific character.

Some color films reproduce vivid hues with high contrast and apparent sharpness. Others are more subtly rendered, subdued and may appear less sharp. In short, each color film works from its own unique palette of colors and tonal characteristics in its attempt to reproduce the natural world. To many photographers, the variety is a hell of frustration in which no film precisely matches their experiences. Film choice is an unhappy compromise.

To the Tao photographer, films present a beauty pageant of talents, each type with its own special attributes to offer. For landscape work in the northern hemisphere — with its frequent dull days and only fleeting bursts of sunlight — high-saturation, high-contrast films such as Fujichrome Velvia produce effective images. Use the same film in the high sun and deep shadows of the Equator, however, and you can expect to be disappointed. There, my preference is for the

Above: To the eye, the trees were green, the distant mountains pale blue, and the sky white. The film's recording of the scene is more an interpretation than a document. Knowledge of a film's color palette is, in the long run, more important than knowing its speed. ∎Canon EOS-1n with 80–200mm lens @ 180mm; f/7.1 at $\frac{1}{250}$ sec; ISO 100 film.

"Something that is now beautiful will change into something ugly, and that which is ugly will become beautiful." The Yellow Emperor

Scanning: hybridizing the silver

Above: This image presents no problems at all for normal photography, but it is extremely taxing for scanning because the sloping lines need to be digitally represented at the highest resolutions or they will appear "stair-stepped." ■Canon EOS-1n with 17–35mm lens @ 35mm; f/8 at ¹/₁₂₅ sec; ISO 100 film.

Opposite: High-contrast slide films need the best scanners for good-quality results. ■Canon F-1n with 20mm lens; f/8 at ¹/₆₀ sec; ISO 100 film.

The best films for scanning are color negative and normally developed black-and-white negative emulsions. Ideally, avoid using color transparency film and films such as Polaroid Polapan or Agfa Scala, with their high silver content.

The high-density of these films is the reason for the problems that can occur. A good slide film will hold information in its shadows well into a density of 3.6 and higher. However, many affordable scanners will be beyond their limits when densities reach a mere 3 or so. This could leave you nearly one exposure stop short of the information you need. And we know what happens when we lose shadow detail: the image begins to look pale and wan because the mid-tones do not have the support they require from the shadows. In terms of Tao, a strong Yin of black is needed as a foundation for the Yang of white. A weak Yin undermines the ability of the reproduction to be convincing.

However, scanning color transparencies is likely to become necessary at some point. If so, use a film scanner or, for critical applications, send images out for scanning on a drum-scanner. For negatives and prints, a good flat-bed scanner is fine, provided it delivers the resolution you need. Just as you should work to the best practicable quality standard when making photographs, so you should scan to the highest available quality. This translates into scanning with the highest possible optical resolution. Desk-top scanners, costing less than a good camera body, can deliver resolutions up to 4,000ppi (points per inch) from 135 format film.

The choice between miniature or larger formats is analogous with the choice regarding the resolution at which to scan. We use

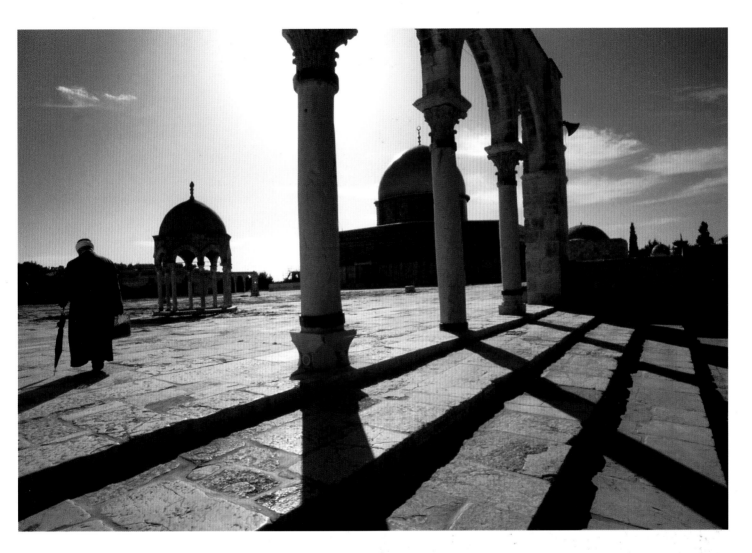

miniature formats when we want portability and will accept "good-enough" image quality – the equivalent of a low-resolution scan. A high-resolution scan delivers quality but at the cost of convenience. This is because the image takes up a lot of expensive storage space: a 135-format original scanned to 2,700ppi, for example, produces a file size of about 28Mb; scanned to 4,000ppi, the original produces some 50Mb of data. Large files are also harder to work with since they demand more computing muscle.

Fortunately, assuming that you have kept the original image, you are not stuck with the first scan you produce. You can always scan again if you need more detail or more quality. Nonetheless, I would always recommend scanning to the best quality you have available – provided, that is, you have the space for storing the

"... from the enlightened perspective everything is part of an undifferentiated primal unity." Chunag Tzu

resulting image files. I normally scan my images with an input resolution of at least 2,700 ppi, and right up to 4,000 ppi – it substitutes the chore of rescanning with the chore of resizing.

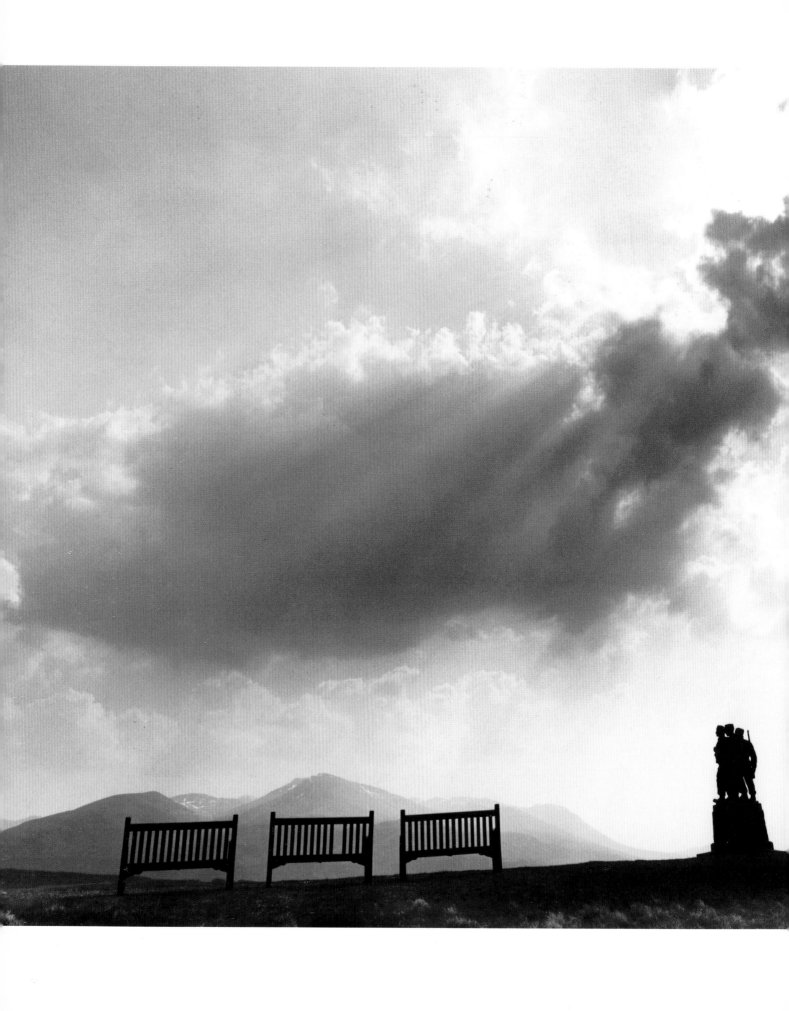

Expose for the heart

Much of the early activity of photography was centered on the problem of controlling the relationship between the sensitivity of light-recording materials and the exposure needs of the subject through such camera settings as shutter time and lens aperture. We have largely forgotten about this, now that we are able to drop film into a camera and point the lens at something with every expectation of obtaining a correct exposure. However, the relationship between materials and subject was not merely a matter of exposure, it also concerned itself with making sure that tonal representation was appropriate.

Today's films cannot match the depth and richness of the tonal range of films of the past, so exposure strategies have evolved to compensate for the limitations of the thinner emulsions used in modern miniature films. Some photographers make extensive use of supplementary fill-in lights, others go through elaborate processing regimes, while yet others use a multitude of filters, particularly the graduated types. But all this effort goes into fighting with light, instead of smoothly flowing with it.

The Tao approach to exposure is simplicity itself. You aim to expose for the heart of the picture . . . and let the rest go. The way to succeed in this strategy is two-fold: first, locate the heart of your image with a precision of feeling; second, learn to let go — do not fight those elements over which you have no control. By accepting the lighting as it presents itself, you need not worry . . . and you will need less equipment.

Ruler on the light

Above: The workshop of a master carpenter in England is suffused in soft light, but the scene is deceptive — the window is still far brighter than the interior of the room. Exposure control means choosing the settings that retain details throughout the entire dynamic range.
■Canon F-1n with 28mm lens; f/5.6 at ¹/₃₀ sec; ISO 400 film.

"Don't overdo it, don't underdo it. Do it just on the line." Andrew Wyeth

The usual approach to exposure is to talk of control, to hand out a list of rights and wrongs, of do's and don'ts: exposure control, the right settings, the wrong settings. And the thinking on this subject is entirely on the technical level, concerning itself with lens apertures and shutter speeds, emulsion foot speed, luminance range, and so on. But in essence, what we are really concerned with is simply how we can ensure that the image recorded is the image we imagined we wanted when we initially took it, how to do it just "on the line." Expressed in this fashion, exposure is clearly as much a matter of the mind as it is of the mechanics of aperture settings, shutter times, and lighting intensity.

To deny the importance of your mind in the process of determining exposure is like taking away one of the legs of a table: it may still stand, but not with any stability. For the Tao photographer, it is natural to regard exposure as a dynamic of all the contributory elements — if you leave any one of these factors out of the equation, then no rounded understanding of exposure can emerge; no reliable control can develop.

As was discussed on page 14, correct exposure depends more on the appropriate balance of underexposed and overexposed areas than on correctly exposed areas overall: unless an image is completely black or utterly washed out, there will be some part that is correctly exposed.

We now need to look at this in detail. An exposure meter — whether built into the camera, incorporated into a digital camera's CCD sensor, or housed in a separate hand-held unit — does two completely independent things. First, it measures the amount of

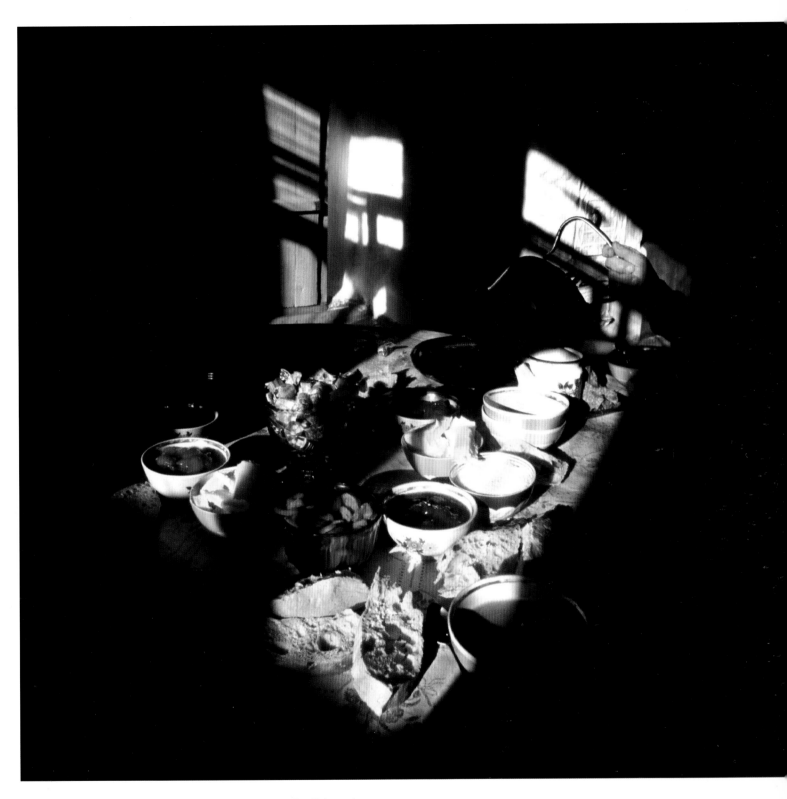

Above: A splendid spread of treats, typical of Central Asian hospitality, greets the guest, and here winter sun shines brilliantly through the windows to create a spotlit effect. However, the film can see only a small part of the luminance range: an exposure that is correct for the sunlit table leaves the rest of the room dark.

■Canon EOS-1n with 20mm lens; f/8 at ¹/₁₂₅ sec; ISO 100 film.

light reaching its sensor: internally, this is an absolute reading of the flux of light energy. Second, the meter performs a calculation: it uses its reading of the amount of light and the variables the user has set — particularly of film-speed — to calculate the camera settings. The idea is that if you set what has been calculated for you by the meter, you will obtain a correctly exposed picture.

Now, how does the meter know what kind of results you want? The answer is, of course, that a meter cannot know anything, much

Below: The secret of coping with difficult lighting is to stop struggling against limitations and to start working with them. It was impossible to retain shadow detail as well as highlight color in this scene, so I made use of the shadows, waiting for the right shape to bring them to life. ■Canon EOS-1n with 24mm lens; f/9 at $\frac{1}{200}$ sec; ISO 100 film.

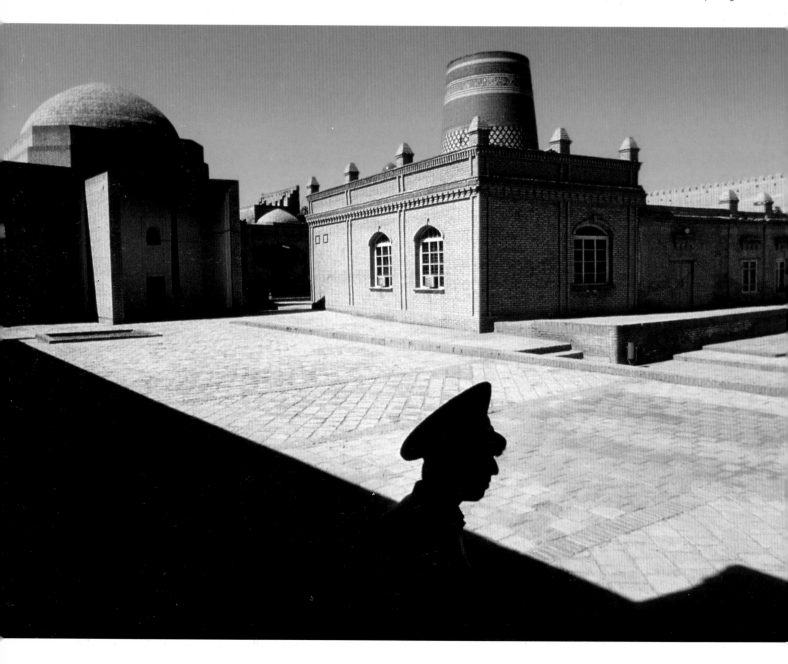

less what type of image you are trying to achieve – so it must be set up to work from certain assumptions. On page 64 we look at metering systems that, in some senses, can indeed make a good "guess" at what you want. Meters are often said to be calibrated to a mid-tone gray, or 18-percent reflectance. Again, this mechanical definition is of little practical help. It would mean that the only thing that could be wholly and perfectly exposed is a mid-gray card – which is about as exciting an image as a tune with only a single note. There will be times when you want results to be darker or lighter than the calibrated standard.

Changing an exposure setting is not dissimilar to changing the brightness control on a television set or computer monitor – you don't change the image itself, only what is seen on screen. On the camera, changing the exposure settings leaves the subject untouched and modifies only the way it is recorded. This may seem obvious, but it worth emphasizing. Changing exposure does nothing to the mid-tones in a scene. If exposure is reduced, all that happens is that the mid-tones are recorded as being darker, the lighter tones record as mid-tones, and the dark tones remain dark. If you increase exposure, the mid-tones in the scene are recorded as being brighter, the dark areas move into mid-tone range on the film, and the high-value tones remain white. The real point is where you want the tones of the scene to fall over the film's range of values.

And bear in mind that exposure is something worth taking a lot of effort over. Inappropriate exposure is the commonest cause of problems in printing or scanning, and it very often reduces photographic ambitions to complete ruin.

The Tao approach is to forget the technicalities and concentrate on the results. The system is simple: you point the meter or camera at a scene, take the picture, and evaluate the result. Is it what you wanted, or is it much too light? Perhaps it is almost right, but just a little dark. Try to work out what camera setting would have given you the result you really wanted. Try again with the new settings and check the results again. If you like them, then you can adjust

"The hen embraces the egg, always mentally listening." Lu Ting Pin

the meter so that it gives you the reading that delivers the types of result you have in mind whenever you take a picture.

This approach to exposure, which, unfortunately, does not have the merit of being either quick or easy, offers the photographer two vital advantages. First, you can no longer take your metering system for granted: you will now see with eyes for exposure (together with composition and timing). Second, you train yourself always to take a scene within yourself, in its entirety.

It is this training of the photographic mind that is the key to confidence with exposure. In support of this, the available technical strategies are several, and these can now be discussed in detail.

Automatic spot metering

When time and circumstances permit, my preference is for automatic spot metering. The spot-meter in my camera takes its reading from a central area that is less than three percent of the total area of the format: the field of view measured therefore varies with the field of view of the lens in use. I aim the spot at the part of the scene I wish to measure from, press a button to take the reading, and then hold it. I next compose the picture again or wait for the right moment to take the picture while holding the reading.

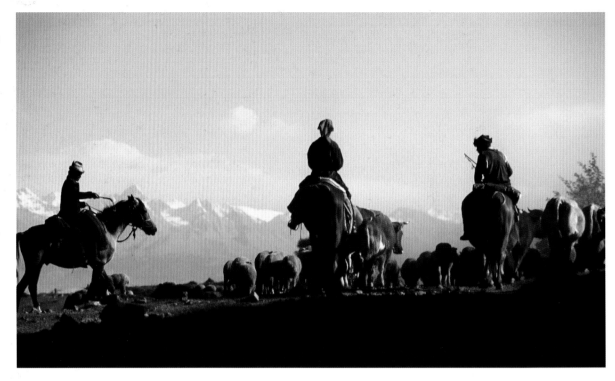

Right: It would have been easy to turn these shepherds into silhouettes. That would be a "correct" exposure, but so is this one, which balances an overexposure of the sky and mountains (leading to the pale colors) with the retention of details in the lower mid-tones. ■Canon EOS-1n with 80–200mm lens @ 150mm; f/4 at 1/250 sec; ISO 100 film.

The skill is in choosing the part of the scene to measure from. Often, it is simply a matter of locating the key area, or heart, of the image: that which must be correctly exposed. This is almost never the brightest or the darkest part, and is usually, but not always, a part lying midway between the brightest and the darkest areas of the scene. It could be the eyes and cheeks of a face, the blue sky of a sun-drenched beach, the margin of transition from bright skin to shadow of a nude figure, the bright plumage of a bird in heavy shade. Almost every scene will supply you with a key area on which the rest of the image depends. Exposing the key tone is like trying a key to the locked room of a potential picture; unlocking the key tone makes sure that the darker and brighter tones fall as needed — like the tumblers of a lock. Then, the image is opened to you.

The reason for using a highly selective exposure reading is to be ready for the occasions when the key tone covers only a small portion of the scene. If the key tone is large, then there is no problem. But if it is smaller than the area you are measuring, you have problems guaranteeing an accurate reading. The best way to avoid this is to read from the smallest practicable area.

A variant of this technique is to "weight" the reading by including varying amounts of darker or lighter tone. For example, I might expect the meter to give me an exposure from the key tone that produces a result slightly brighter than I want: thus, I need to reduce the exposure. I do this by including a small area of brighter tone in the reading. Technically, what I am doing is tuning, or weighting, the reading by a factor equal to the proportion of the area of the meter reading covering that area.

The beauty of this technique is that calculations are banished. There is no need to remember figures for dynamic range (who wants to think about one- and two-third stops in the blur of the movement?) and no need to take multiple readings and wait for the camera to figure it out (who wants to take four exposure readings before shooting a picture?). When you free yourself from calculations, it is easier for the image to guide your hand.

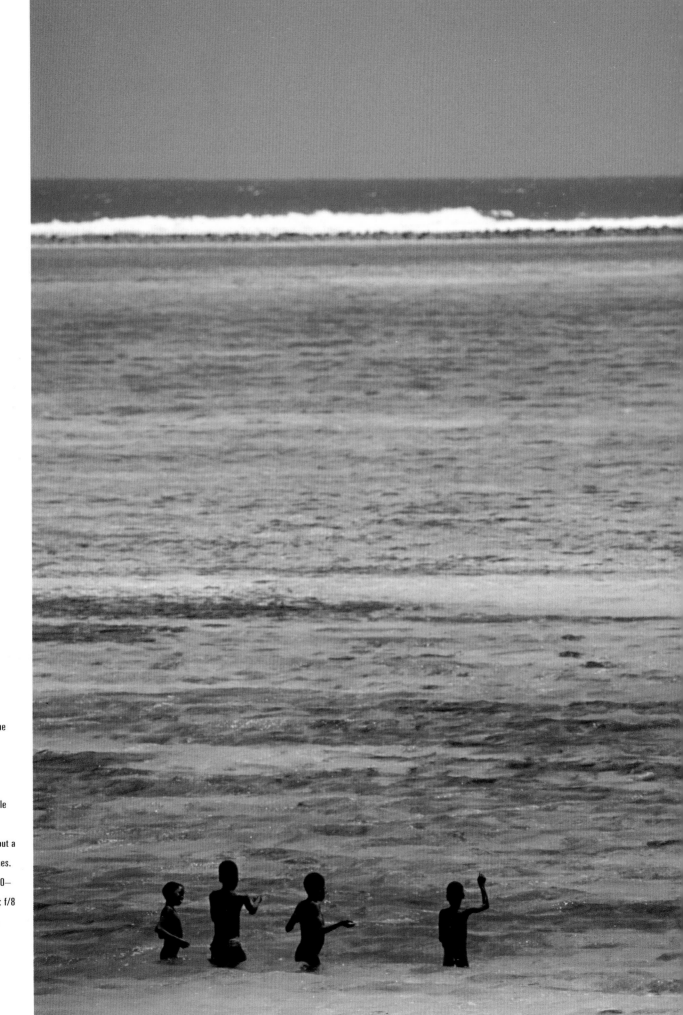

Right: One of the little miracles of photography is that color film can record more colors than the eye can see, given the appropriate exposure. In the brilliant equatorial sun, the waters in this Zanzibar lagoon were pale and weak, but a slight "underexposure" brings out a full palette of aquamarines. ■Canon EOS-1n with 100–400mm lens @ 400mm; f/8 at $^1/_{350}$ sec; ISO 100 film.

Averaging and center-weighted metering

You will hardly ever encounter a true averaging metering system these days. A few hand-held meters may claim to be averaging, but in fact nearly all give more weight to the reading from the center of the field of view than they do to the periphery of the frame. Center-weighted metering systems take in a large field – either the entire

"… the limitations of photography are in yourself, for what we see is only what we are." Ernst Haas

field of view of the lens, as defined by the focusing-screen, or an angle of at least 40 degrees – but they then place more emphasis on the reading from the center of this area.

One type of true averaging metering measures the light that falls, or is incident on, the subject. This is almost always taken with a separate hand-held meter. The theory is that you ignore the reflective qualities of the subject and, therefore, how the subject reacts to the incident light falling on it, and in this way you obtain a correct reading for subjects that are either unusually dark or very highly reflective. For example, the same amount of light falls on two adjacent areas – one matt black, the other metallic white. A reading taken solely from the black or the white area would lead to the reproduction of a mid-gray tone. An incident-light reading, however, makes the black appear black and the white appear white.

However, it is worth noting that all circumstances in which a center-weighted metering system is effective can equally well be served by spot-metering system or by multi-segment metering system, which is the next method for consideration.

Multi-segment metering

Multi-segment metering, or so-called "smart" metering, takes a complicated approach. For the user, however, it is transparent: you just point and shoot. The exposure meter splits the measurement area into separate sectors, or zones: some cameras use more than 20 zones. When faced with a scene, the meter takes all 20 or so readings and looks up tables of data previously calculated from analyzing thousands of photographs. From this it simply reads off the preferred exposure and sets the camera accordingly.

Surprisingly, results from this coldly computed method are often accurate. After all, many pictures do fall into a pattern: a dark background with strong light from one side often means a portrait by window light, calling for an exposure based on the bright area. High brightness in the lower half of a scene with an evenly darker area above usually corresponds with a beach or snow scene – which call for similar exposure settings.

But, of course, there are occasions when this smart exposure system does get it wrong. It is only as reliable as the original data that is used for creating the look-up table is photographically sound. It is difficult to know what the meter is "thinking" and there is no substitute for having a very good idea yourself of what the reading ought to be. And if you know that, then what need is there for the smart metering?

For all that, I do use smart metering when conditions are rapidly changing – a street carnival in bright sunshine, for example – and I have no time to take the time and care I would like to. In those circumstances, the metering on my camera gives me more usable images more often than I could. And smart metering is certainly far more reliable than any center-weighted or averaging system.

Exposing black and white

Apart from the reasons already discussed (*see pp.58–64*), there is another reason for not relying on the usual technical definition of an exposure meter in terms of calibration to a mid-tone gray. Black-and-white films and, to a lesser extent, color negative, have slightly different requirements from color transparencies. In practice, then, what we really measure is the final effect of an exposure on the print: we are not concerned with the light itself, but with the resulting photograph. This is the meaning of Cézanne's astonishing statement, for he was ultimately concerned only with the painting

"Light does not exist for the painter." Paul Cézanne

Below: On hot days in Zanzibar, a favorite pastime of boys is making the biggest splash possible when diving into the sea. With a low sun and high contrast, the easiest approach is simply to get the water or similar mid-tone region correctly exposed - everything else then falls into place. ■Canon EOS-500N with 28–70mm lens @ 28mm; f/8 at $\frac{1}{250}$ sec; ISO 400 film.

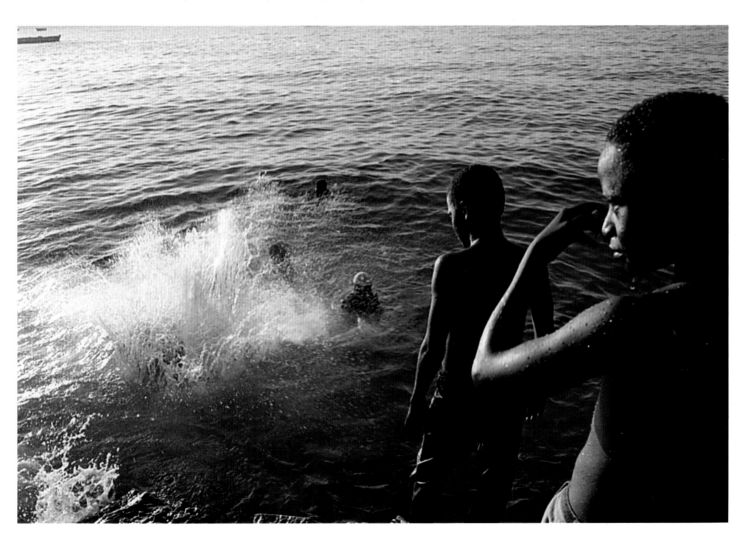

itself. He did not mean, of course, that light does not exist, but that, for the painter, the only important thing is the painting.

With the primacy of the end-product in mind, it is worth stressing again that exposure is worth taking the trouble over, even with black-and-white film, which possesses a wide exposure

"The sun is but a bell ringing out light." Leonhard Euler

latitude. This means that it is more tolerant of exposure "error" than is color transparency, which has virtually no margin for error. But the fact is that a lack of precision in exposure wastes more darkroom time than all other imaging problems put together. If you learn to expose black-and-white film as accurately and precisely as

you do the most demanding color transparency film you can be sure of having an easy time in the darkroom. Instead of having to make test strips for every new image, you know that, assuming you do not alter the size of the enlargement, the printing time for any new shot will be within a second or two of all your other shots. This is the beauty of working with consistently exposed negatives, and there is no reason why you should not expose black-and-white negatives just as precisely as you do color transparencies.

Much skill is exercised in the darkroom dealing with negatives that are too thin (less exposure than required) or too dense (more exposure than required). But the best use of the craft skills needed to correct these problems, called burning-in and dodging, are in creating subtle changes in tonal balance and composition in the print; not in compensating for ill-judged overall exposures.

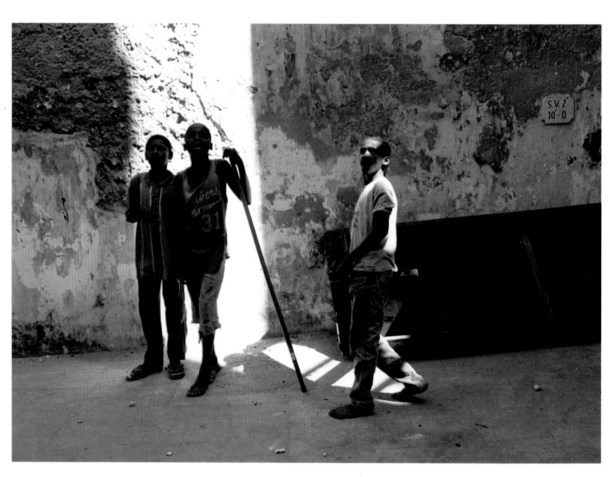

Right: In high-contrast scenes, a photograph is more of an interpretation than a record: the task of exposure control is to shape that interpretation. This scene, taken in Zanzibar, was in fact much lighter and brighter to the eye — but a light-toned print would look overexposed. ■Canon EOS-500N with 28–70mm lens @ 28mm; f/8 at 1/250 sec; ISO 400 film.

In the end, there is much to be said for the classic photojournalist's attitude to exposure meters: do not use them at all. Long experience with a standard combination of film and developer in numerous situations plus — crucially — a practiced sensitivity to light, is enough to ensure that exposures are set which result in easily printable negatives. Indeed, today's reliance on exposure meters means that even when a meter is indicating obviously incorrect exposure settings, many photographers simply do not notice and slavishly follow the read-out or fail to override the automatics. So it helps to learn to translate a feeling for light into camera settings. My favorite light for color work translates into f/6.3 at $\frac{1}{125}$ second for ISO 100 film, early or late in the day, or at midday with a half-overcast sky. Indoors, the low, soft light I like for nude photography translates into f/2.8 at $\frac{1}{60}$ second for ISO 400 film.

Unfortunately, the best trained minds are still not accurate enough or as reliable as today's exposure meters, and with the widespread use of zoom lenses with variable apertures, through-the-lens (TTL) metering is essential. But there is a middle way. It is best to avoid both the extreme of never using a camera meter and the other extreme of an over-reliance on a meter. The former is not accurate enough for working in color, while the latter will eventually dim your vision. Seeing photographically involves not only a sensitivity to composition and timing, it also calls for awareness of how the scene will translate into the photograph.

If there is a correct setting, it is one that gives you the results you want. In this single setting you have one chance to distribute the lights, darks, and middle tones. The settings of aperture size and shutter time are like a magic wand — a single wave controls the appearance of the whole scene. And if this is true for black-and white-film, it is doubly true when you are working in color.

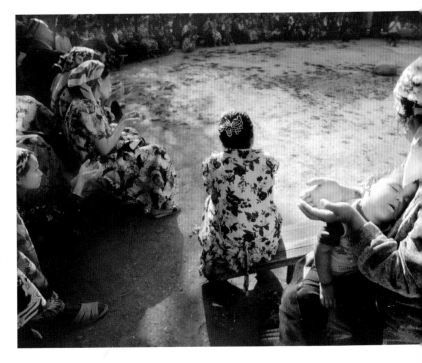

Above: While important elements of this image are strongly lit, it was crucial not to lose the richness of detail in the lower mid-tones. Here, I allowed the mid-tones to have their full value, while permitting the highlights to become overexposed. Viewers will usually tolerate overexposure, provided it is confined to small areas. ■Canon EOS-1n with 17–35mm lens @ 24mm; f/8 at $\frac{1}{30}$ sec; ISO 100 film.

"The wise seem confused, knowing the imperfection of their understanding." Lao Tzu

Exposing color

Color photography is a sleight of hand. It pretends to record a scene, while in most situations it does nothing of the sort. We think we are in control of color materials, but in fact it is they that have trained us. Having learned, for example, how limited is the ability of color transparency film to record a range of high-to-low values (perhaps a

> ## "Color is joy. One does not think joy. One is carried by it." Ernst Haas

brightness range of no more than 1:5) we search for scenes that strain that range as little as possible. Or we go through elaborate performances to reduce the range by using supplementary lighting or graduated filters. Color negative film, on the other hand, can record a wider brightness range (say, 1:32), but this is translated on to a paper print with a much lower brightness range (say, about 1:16). Nonetheless, we have learned to accept the print as a reasonable facsimile of a real scene. The wise photographer soon recognizes that these visual tricks are constantly in operation and so learns to work with rather than against them.

One consequence of the limitations of the materials is that most images consist largely of areas that are not "correctly" exposed. The role of incorrectly exposed areas is to reveal and define the correctly exposed ones: needless to say, these correctly exposed areas are the key tones, since that is where the weight of much of the meaning is carried, where the photograph does most of its work.

As a result, photographers have to balance in their mind two conflicting forces when working out exposure. They need to locate the key tones with confidence and precision – using the spot-meter option on a camera is ideal for this, as it makes you focus on finding that very same tone. However, you must be aware that over-concentration on "correct" exposure can, perversely, fix your mind on what is "incorrect," which is not constructive.

The fact is that we must have "incorrect" in order to position the "correct." The Yin of "incorrect" tones delineate and define the Yang tones of "correct." Far better, then, to abandon the notion of "correct" and "incorrect," and focus on tonal totality.

The essence of exposure is attaining a balance of the Yin and Yang tones for the meaning of a particular image, and is founded on the harmonious totality of its light, dark, and key tones.

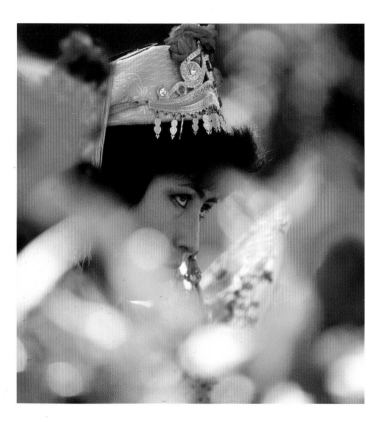

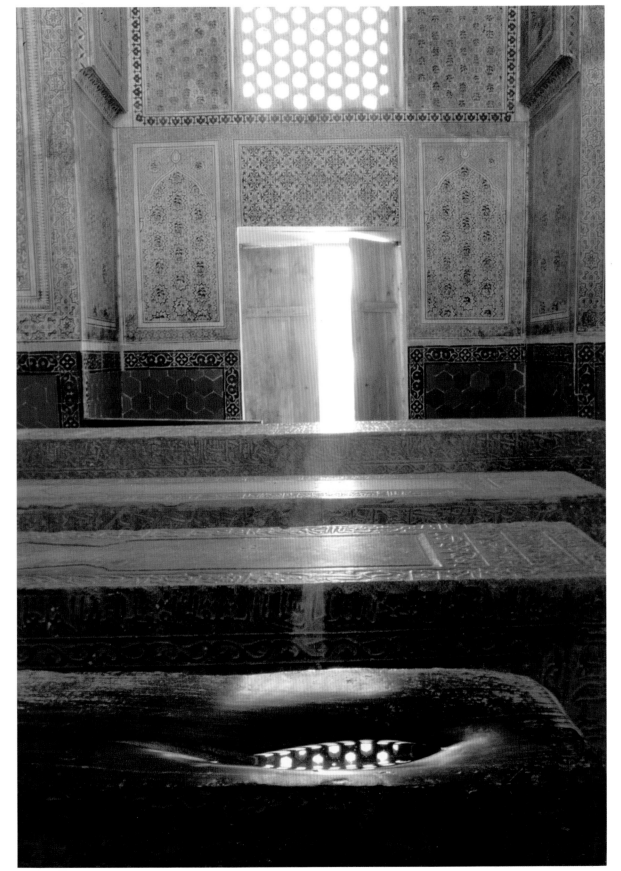

Right: Paradoxically, color photography is at its best with monochromatic images, such as this mausoleum in Uzbekistan with its delicately cool pastel shades. I used a shift and tilt lens to keep the verticals parallel, yet obtained enough depth of field to encompass the near tombstone and the distant door.
■Canon EOS-1n with 24mm lens; f/16 at ¼ sec; ISO 100 film.

Left: Newly wedded girls are brought out to parade on Independence Day in Uzbekistan. The bright midday sun makes photography difficult — you select the subject as much by the lighting that can be recorded on film as by the subject herself.
■Canon EOS-1n with 80—200mm lens @ 150mm; f/4 at ¹/₂₅₀ sec; ISO 100 film.

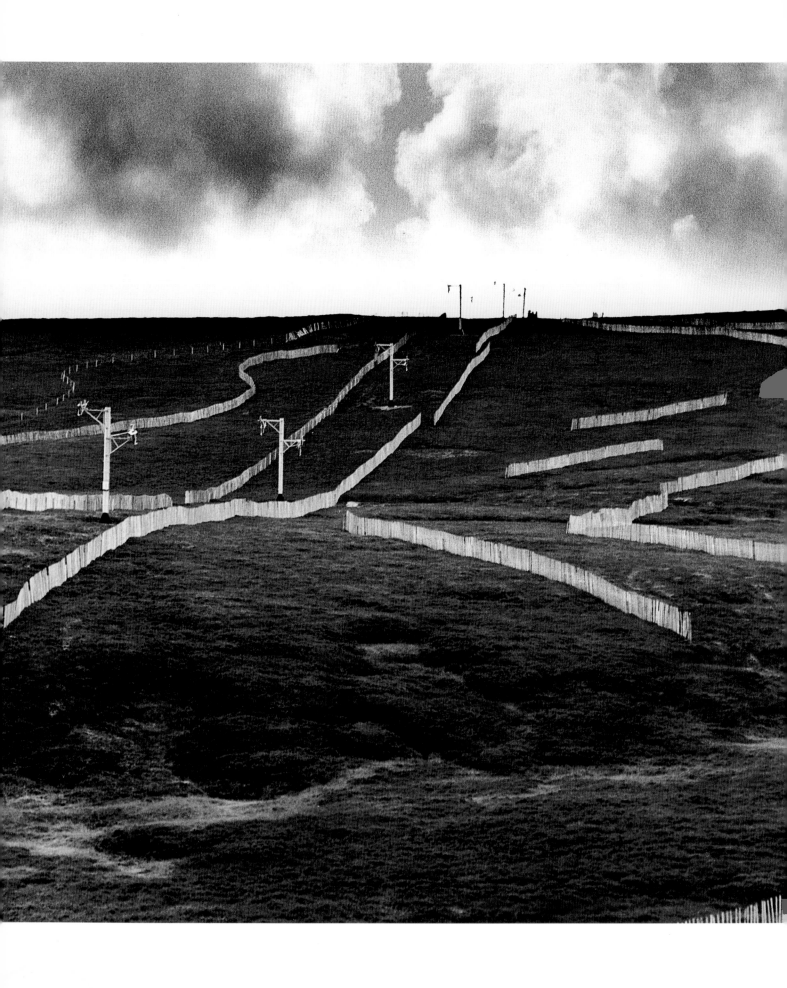

Finding the Way

It is exciting when first learning about photography to discover just how easy it is to control the content of a photograph. And it is so satisfying when you fully realize that it is your knowledge, thoughts, and actions that shape a photograph. It is the photographer's contribution, after all, that makes the difference between a mindless machine and an instrument capable of creating beauty. This is part of photography's attraction and a large element of its challenge. But within this knowledge lurks a danger. It is easy to slip into a seductive speculation: perhaps it is possible to be fully in control of the photograph and that all that is necessary is to learn how to command – totally – that power.

And this speculation is reinforced by the allure of digital photography. Being able to access each and every picture element of an image, it is possible to control its every atom, to bring its content and its message fully into our grasp.

The Tao of photography is to avoid the false allure of taking control. For total control is a chimera. This does not mean you should do nothing; the notion is something much more positive. Rather, it is to let it be, to allow a situation to find its own level. As you relinquish control, you gain power. This allows space for naturalness. Spontaneity replaces artifice. The Tao of photography is, therefore, to allow Tao to assert itself, to allow Tao to guide you and take your tools in its hands in order to express itself. The result of letting go is, paradoxically, to produce photography that is more satisfying for you.

Creative intelligence

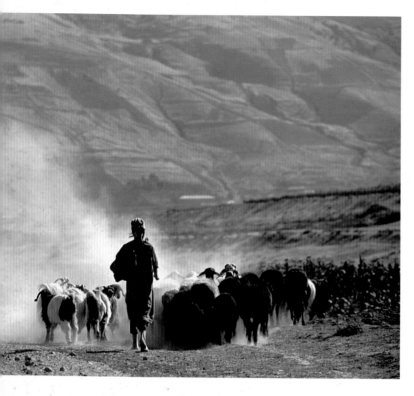

Above: Watching a cloud of dust approaching, I guessed where the flock of goats would cross. For once, I was right. Was it luck or was it more that chance favored the prepared?
■Canon with 80—200mm lens @ 180mm; f/4.5 at ¹/₁₂₅ sec; ISO 100 film.

"The enlightened attention rejects nothing nor welcomes anything – like a mirror it responds equally to all." Chuang Tzu

At the heart of the notion of creativity in art is the question of whether creative people have specific skills devoted to making the most of their innate abilities. We have intelligence quotients that measure problem-solving abilities, and we have emotional intelligence, the skills needed to relate and negotiate with other people. So do creative people have creative intelligence?

Abilities are different from skills. Abilities tend to be innate, something you are born with that lie latent until exploited – although we can improve them, to a degree, if we work at them. A small, delicate person has limited abilities as a weight-lifter, which no amount of skill-building or technique can overcome. A large-framed individual capable of becoming an operatic bass has a poor future as a steeple-chase jockey. Skills, however, must be acquired or learned. They are built on the foundations provided by your abilities. Given that you are a large person, you can be taught to lift weights; with a small athletic body, only training will take you from the farmyard to the racecourse. Given an ability to remember colors, you can learn to print accurately. And once skills are acquired, they can be improved on.

It appears that being creative is more an ability than a skill, more a feature of the personality that you are born with than a knack you can acquire. Creative intelligence means, then, the skills – that can be acquired or learned – to make the most of your innate creative abilities. So, if creative intelligence is a set of skills, it follows that we should be able to identity the individual components and set about improving them, if we wish.

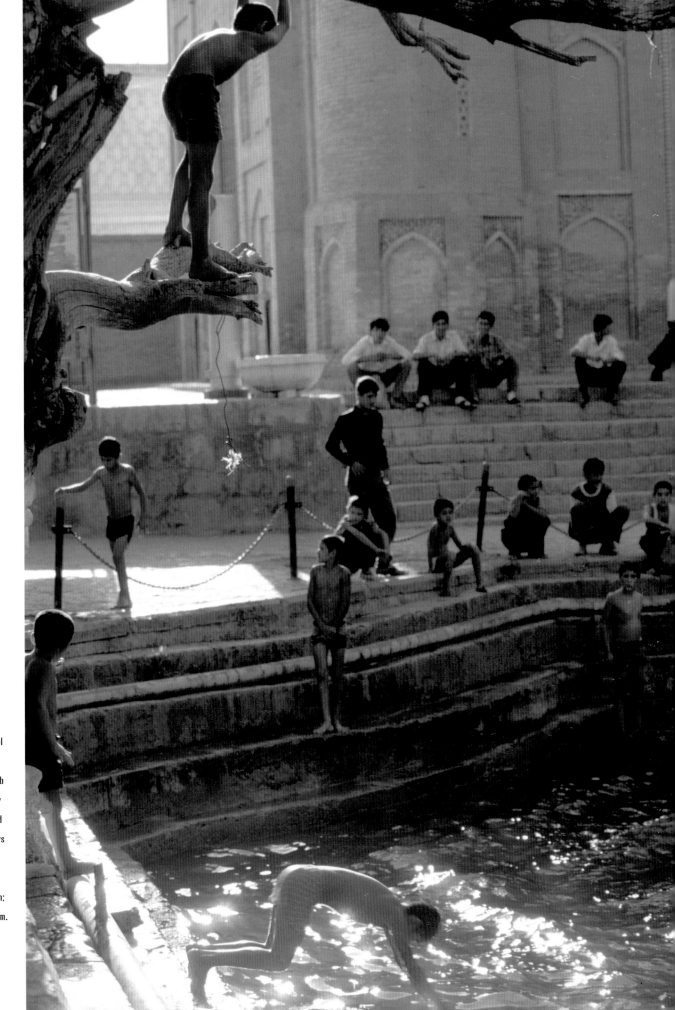

Right: Taking a tea break near this centuries-old pool in Bukhara, Uzbekistan, I could have missed a superb picture-making opportunity had I relaxed too much and not heard the sound of boys diving into the pool.
■Canon EOS-1n with 80–200mm lens @ 80mm; f/5.6 at ¹⁄₂₅₀ sec; ISO 100 film.

Here, then, we reach the core. The skills that I suggest might constitute creative intelligence are based solely on the known personality traits of creative people, determined by psychological investigation. The notion is simple: the way to improve your performance is to work on and develop any natural traits or inclinations that you already have. Therefore, if you have a leaning in a particular direction, you work to enhance and to enrich it. (Conversely you should try to close down harmful or obstructive tendencies . . . but that's another story.)

bring in other ideas that are more or less related – they associate new ideas with the original thought and, as a result, have the ability to see things as a more rounded whole.

> "I think you have to use your eyes as well as your emotion, and one without the other just doesn't work." Andrew Wyeth

Associativity: seeing the whole

One of the key characteristics that seems to be common to most creative people is that when they consider an idea, they tend to

More than this, the thoughts of creative people tend to move freely from one idea or notion to another. Their minds jump about and there maybe no obviously discernible straight line in their thinking. Creative people also seem to be better at seeing the links between a range of ideas. Creatively less able people, on the other hand, are unlikely to be distracted by associative thinking; their thought processes are more ordered and predictable, and their cognitive processes are steadier and less challenging.

Sadly, creative people can fall victim to criticisms that they are chaotic thinkers, or be made to feel inadequate because they are flighty, dippy, or whimsical. And there is something in that criticism: too much whimsy can be unproductive.

So creatively intelligent people encourage and nurture in themselves their apparently crazy thought processes. They allow their minds to work spontaneously, to find linked associations, bring seemingly opposing notions together, and toy with

"what if?" questions. Bear in mind that in art, not only can black be white, at times it should be. In addition, the creatively intelligent must ignore criticisms that their thinking jumps about wildly: unpredictability is the wellspring of artistic productivity.

Tolerating ambiguity

An important but not obvious feature of creative people is their ability to tolerate – and even to enjoy – ambiguity. They can accept that there is not necessarily a single "correct" answer and can hold two quite contrasting views or scenarios at the same time. They know that clear answers are as rare as free lunches. Contrast that

Opposite: The play of light and shadow lifts an otherwise ordinary market shot, taken in Kyrgyzstan. ∎Leica M6 with 35mm lens; f/5.6 at 1/60 sec; ISO 400 film.

Above: An orphanage in Romania had so few toys for so many children that it kept them all behind a locked door, to be opened only at set times. I could have set up a shot to make a point about the poor facilities there or waited for a more subtle, softer message to present itself. ∎Canon F-1n with 20mm lens; f/5.6 at 1/15 sec; ISO 400 film.

with people for whom everything is resolved into the bottom line, for whom no answer is correct unless it is unequivocal, as cogently argued and as well considered as a Supreme Court judgment.

The creatively intelligent person works consciously with ambiguity, playing with it as a playwright builds dramatic tension. It may not always be enjoyable, for sometimes there is little clear water between ambiguity and gnawing uncertainty – but artists know they have to walk through the fog. The process means learning how to let go, how to allow a situation to find its own level or to establish its own resolution.

For the sensitive individual, learning to tolerate ambiguity means not settling on the first idea that comes to mind. It is necessary to cherish – even learn to enjoy – the fact that after teasing and throwing a concept around, looking at it from a variety of different angles, it may still stubbornly refuse to settle into a shape that can be worked with. That just means that a little more work needs to be done. Creative intelligence knows that ambiguity is the birthplace of artistic cogency.

"Fear . . . keeps thousands of pictures from passing through the lens." John Durniak

Flexibility and invention

You should expect the characteristic of flexibility to be part of the broad palette of creative intelligence. For a start, it is most certainly the seedbed of invention. Flexibility means that you are readily prepared to change your mind, to accept that the solution that only yesterday seemed to be the "True One" can be substituted for another today, that when you set off in one direction you are prepared to change your heading without a great groaning of spars and a flapping of sails. People who are not flexible are good at . . . not being flexible: these are the types of people who make it to the

Opposite: Drink is one of the cheapest forms of entertainment in the former Soviet Union. But the patterns of shadows suggest another type of photograph is intended.
■ Leica M6 with 35mm lens; f/8 at 1/250 sec; ISO 400 film.

Above: Few things so clearly articulate the struggle of the common people after the collapse of the Soviet Union than the financial difficulties pensioners now find themselves in. Nearly overnight inflation has made their savings next to worthless, and they are forced to sell anything, even single cigarettes, in order to make a living. This image was taken in central Asia.
■ Leica M6 with 35mm lens; f/5.6 at 1/60 sec; ISO 400 film.

top and everyone hates them for it: they lose wars, have no friends, and they beat up cashiers who refuse to accept their checks.

Of course, artistic types can also be known for being a little too flexible, too easily swayed by fancy – as able to stand up for themselves and their ideas as a piece of string can stand by itself. So the creatively intelligent knows when it is necessary to change course, when to adapt to restless situations. But they must also know when it is time to stand and fight their corner, when to unsheathe their claws so that they can defend their creation. Successfully creative people are supremely skilled at balancing the need for encompassing, adaptive responses with the ability to be firm and determined when the occasion warrants it.

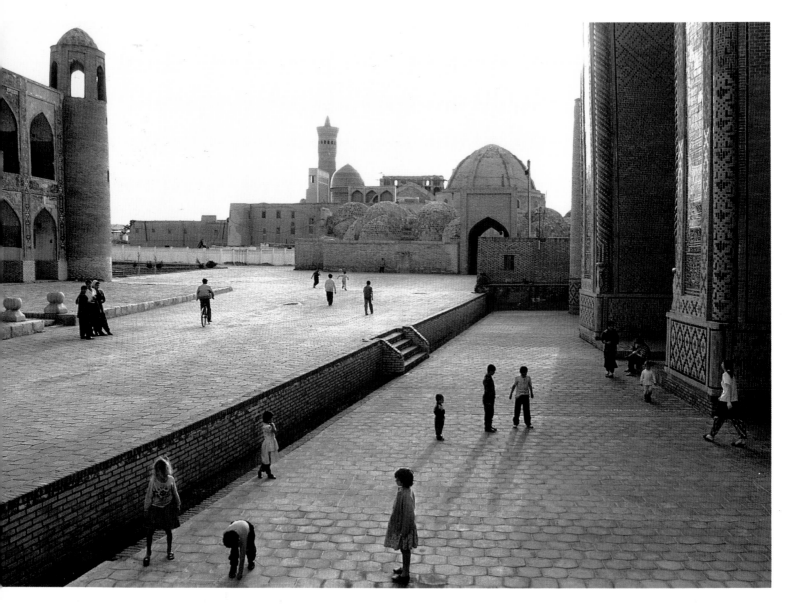

Above: You can approach architectural photography rather clinically — as purely a depiction of buildings — or you can try to show how life interacts with the built environment. In Bukhara, daily events take place in historical surroundings. For just an instant, after an hour's watching, this image arranged itself.
■Canon EOS-1n with 24mm lens; f/8 at 1/125 sec; ISO 100 film.

Incubation and maturity

Many processes – from bread-making to wine production – need a period in which the key components are given a chance to ripen, to mature and blend together before the fruits of the work are ready to be sampled. Creative processes are the same. Incubation is a stage between the preparatory – in which materials and ideas are

"I wanted to insist on reality, but it revealed itself to me in too many of its guises." Peter Korniss

gathered together – and the production – when the ideas and materials are fused by the artist to bring forth a new creation. The question here is how to make the incubation effective and efficient, and perhaps even to guarantee that it produces useful results.

Creative people use differing strategies. One is to generate a state of tension and absorption: a combination of focus and suspended agony, as if the solution is perpetually just out of sight, until, in an apocalyptic moment, it finally comes within reach. Artists and writers around this stage are often to be found drunk, morose, viciously angry, or despairing. Another strategy is consciously to use the unconscious to do the work, to gather the materials, and to tell the mind to get on with it. The artist can be found dreaming, meditating, or just sleeping. This strategy is much less demanding than the first, but not necessarily any less effective.

One technique I use is to picture that the problem I am working on is literally on a back burner, quietly bubbling away at the back of my mind, with a few brain cells assigned to keep a watching brief. I tell the ganglion to report back if anything interesting develops. Or I set up a subcommittee (of ganglia, of

course) and tell them, "Here is the problem, get it sorted by tomorrow morning (or whatever time is appropriate)." Like any other subcommittee, those made up of brain cells need a reasonable period in which to complete a given task. The beauty of this technique is that you can get on with any jobs that may be more pressing, and so need to be on the "front burners."

It is not that simple, however, for some struggle is needed: perhaps the greater the struggle, the better the creation. But that is fortunately not always the case. Some of the most creative thoughts can enter the mind seemingly unbidden, like a bird glimpsed in beautiful flight. But more often, a closer analysis will show that the creative person had been slowly collecting all the

elements – perhaps over a period of many years – which needed only a final touch to be brought to fruition, apparently effortlessly. Thus, successful incubation needs constant attention – like the hen listening to its egg even as she pecks around the yard.

Focus and concentration

Creatively intelligent people often have the most amazingly ability to concentrate: they seem to be able to exclude anything and everything from their mind apart from the task in hand, whether it is tweaking the lighting in a studio set-up, waiting for the very peak of the action to unfold as a sports event builds to a crescendo, or patiently watching the fluctuating daylight for the precise moment that a landscape reveals itself in its complete and total glory.

The creatively intelligent are not embarrassed to be found totally absorbed in their work, though each has to find the strategy that best suits temperament and personality. Some may have to work themselves into a panic, for example – midnight before a 9am deadline and they still have not made a start, yet eight hours later it is all done. And they find that all the dithering about in the previous weeks was but the preparation for that final burst of incredibly focused, profoundly concentrated creative work.

Creative intelligence, then, is knowing how to control the ability to focus fiercely: when to begin and, just as importantly, when to stop the focus. Great promise has been known to sink into the dust of oblivion simply because the artists did not know when to call a halt. The work may have been brilliant, but the artists had to work on and on, missing deadlines and opportunities, because they would not allow themselves to be distracted from their search for

> "He has to become one with the drama unfolding before him – and sometimes with the anguish and terror that is part of it." Yves Bonnefoy

perfection by the petty concerns of, say, exhibiting their material or paying the rent. Until life got bored waiting and passed them by. The metaphor for focus is the laser beam: concentrated and intense, every particle of energy moving in perfect step with each other and none of the spreading out that wastes energy.

Status ante quo

From eight years of teaching and working with hundreds of very bright and talented students, it is clear to me that there is no simple predictor of how creative a person will be. Some are very

Above: With movement almost too quick to follow, I needed an autofocusing lens for this shot, taken in freezing conditions in an Uzbekistan market. The original is in color.
■Canon EOS-1n with 28–70mm lens @ 50mm; f/4 at ¹⁄₁₂₅ sec; ISO 100 film.

"To examine oneself makes good use of sight." Chuang Tzu

talented and full of ideas, but they never settle, their development is hesitant, and finally they do poorly: not just in terms of their grades; more importantly, they fail to live up to their own standards. Others appear to be less creative, but such ideas as they do have, they develop fully and effectively. Of course, many other factors are also at work, such as access to money or relationship crises. But what is certain is that all would benefit from a better understanding of the nature of creative intelligence.

The following pages present concepts that link aspects of creative intelligence with different modes of working. It may help you to understand how to locate your preferred approach to photography within a wider scheme of practices.

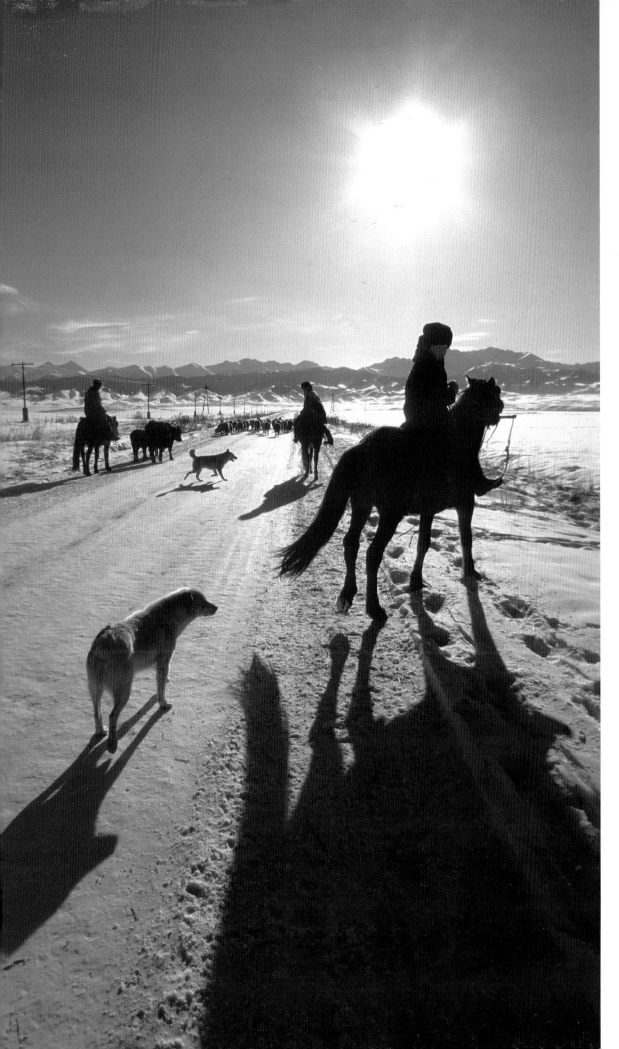

Left: Following a flock of sheep in temperatures of 0°F (-20°C) in Kazakhstan is no joke; nor does the bare and brilliant sun make for easy photography. In these circumstances you have to let instinct take over — certainly my brain does not work in such conditions. The original is in color.

■Canon EOS-1n with 20mm lens; f/11 at $\frac{1}{250}$ sec; ISO 100 film.

Modes of working

At its most fluid, great photography results from a long dance between the photographer and the photographed – to the tune of the photographic process. The dance could be a slow and delicious waltz; equally, a whirling tango. Temperaments and circumstances choose the dance, events and the run of life shape the photography.

One way to characterize the range of photographic approaches is to imagine a scale that, to one extreme, stretches from photographs that are entirely found – whose content is not in any way controlled – to the other extreme in which every single element is constructed and carefully predetermined. In terms of Tao, the first pole, that of the "found" photograph is Yin, while control and construction are more characteristic of Yang.

So, if Yin is represented by the receptive and the responsive, then photographers who open themselves to life and all that it offers – seeking to record the truth as they see it, with no intervention or artifice – are themselves essentially Yin in nature, and thus produce work that is also Yin in nature. It is fascinating to note that such photographers – who are often found working in the field of photojournalism or documentary photography – are typically those who want to improve the world, those who sympathize with

> "This summer . . . I saw more colors there than before." Vincent Van Gogh

the plight of the less fortunate. Such photographers love to fight for the dispossessed. Such passions are essentially Yang in character, that is they are assertive, energetic, and anything but passive. From the Tao perspective, this balancing of Yin and Yang is almost predictable: the natural partner to the Yang-derived wish to improve

Left: Photographing people calls on people skills as well as strictly photographic ones. For some, this mode of working is too emotionally demanding – they would rather move bowls of fruit around. For others it is a joy, a bonus on top of the pleasure they derive from the photography.
■Canon F-1n with 28mm lens; f/5.6 at 1/60 sec; ISO 100 film.

Above: A patient wait by a poster-strewn wall in Arles, France, gave me this image. This way of working is fairly easy — involving nobody else, it needs no cooperative effort. But it is a mistake to believe in its objectivity. You still make many choices that influence the outcome and content of the image.
■Canon F-1n with 50mm lens; f/5.6 at ¹⁄₆₀ sec; ISO 100 film.

Above: An ordinary roll of garden hose forms a composition with a handful of fallen rose petals. Ordinary, yes, but just waiting to be seen, its significance grasped ... for a photograph to be made. But in its making, much choice is exercised. No image is utterly found or truly random.
■Canon EOS-1n with 50mm lens; f/5.6 at ¹⁄₆₀ sec; ISO 100 film.

"To create one's own world in any of the arts takes courage." Georgia O'Keefe

the world is not photography that is essentially Yang in nature – since this produces highly constructed images – but Yin photography, which interferes in the process only minimally.

You could look at commercial and advertising photographers for further evidence. Their work is very Yang in nature. There is no hesitation when it comes to manipulating the image, and the photographers hold sway over every detail until it is exactly as required. Such work is the very opposite to that of photographers who shoot as invisibly and noiselessly as possible to minimize their influence on what they are recording. Not surprisingly, photographers who produce highly Yang work are typically Yin in their political and social views. They tend, in the main, to accept the status quo – in fact, they usually benefit from it and, thus, have vested interests in maintaining it. Also, they usually have no particular expectations of changing the world through their work.

Photography that is highly constructed could, of course, be used to influence people to improve the world. Such a process doubles the Yang influences and is, from the Tao viewpoint, arguably too Yang. As it happens, advertising experience shows that people can be persuaded to do something that benefits them – a largely Yin response – far more easily than they can something that benefits others – a positive Yang response, which is preferably achieved with a photograph mainly Yin in character. Work that is too Yang – constructed to promulgate a view or be critical of certain stereotypes – often comes out as heavy-handed, hectoring, and having little to say beyond the obvious.

Now, the Tao view is that in anything and everything there is some Yin and some Yang: what varies is the balance. Furthermore, that balance changes according to the depth at which you analyze

or investigate. You can work in a way that completely ignores such factors — however, the smart money is on those who add the insights that Tao affords to their repertoire of concepts and models and, in so doing, increase their understanding of photography. Photographers who begin to understand the forces within themselves and their interplay with the forces operating outside will find an improved capacity to produce satisfying work.

Below: It is extremely difficult to photograph simply, to minimize distractions. Unlike a painter, photographers cannot paint over what they do not wish the viewer to see. ■Canon EOS-1n with 50mm lens; f/8 at 1/15 sec; ISO 100 film.

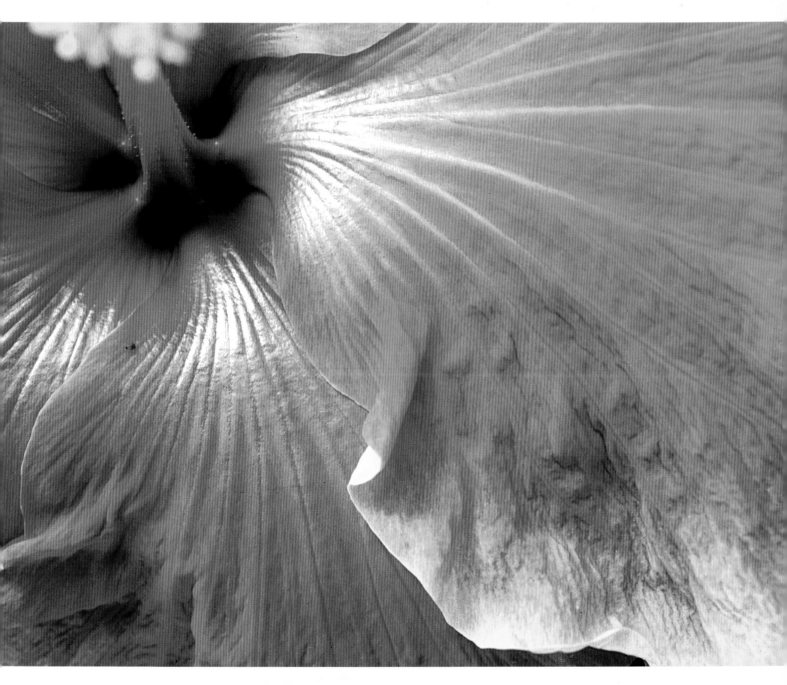

Uncertainty and Tao

There are some photojournalists and documentary photographers who from time to time will mention Heisenberg's Uncertainty Principle – usually in a type of forlorn or despairing voice. This states, in effect, that you cannot know or measure at the same time and to the same degree of accuracy both the movement and the position of an electron. This is because as the certainty of one measure increases, the uncertainty of the other must also increase. Photojournalists extrapolate from Heisenberg's Principle the notion that it is fundamentally impossible to reach their ideal – that of being able to photograph a subject or situation without in any way affecting or influencing the events that they are observing and recording. It seems, from Heisenberg, that you necessarily change the world through the simple act of observing it. However, not only does this argument misrepresent Heisenberg's principle, it is simply not a point of view a Tao photographer would want to share.

What Heisenberg was saying in the Principle is that the more precisely you try to measure one particular thing, the less

> "The Wise succeed without intending to do so." Lao Tzu

accurately you can measure a related factor. This applies to normal-sized objects as well as to very, very small matter, such as photons. In order, say, to measure the speed at which an electron is traveling, you have to do certain things that make it difficult to be sure about the electron's exact position. And the more accurately you try to measure its speed, the less you know about the particle's position in space. More than that, it turns out that the more you try to find out about the position of an electron, the more it behaves as if it were a particle. And if you turn your attention to its speed, the more the electron behaves as if it were a wave.

> "Those who oppose the flow of Tao end up being called 'unlucky.'" Tao Te Ching

Now, this observation has strangely familiar resonances for the Tao photographer, resonances that ring through the whole question of photographic styles and approaches. It is a fairly common experience of studio photographers that a certain arrangement or set-up they have worked hard at all day just "refuses" to come together. After a frustrating struggle to get it right the photographer finally gives up and, moments later, suddenly comprehends clearly a better way to achieve the image he was striving for. Documentary photographers will often try to persuade their subjects to ignore their presence, and that of the camera – but the more they implore, "Pay no attention to me . . . just carry on with your work," the more they play up to camera. Sometimes, the only solution in this type of situation is to join in with your subjects' activities. You may then be surprised at just how soon they accept that you are part of what is going on and tire of fooling around.

The paradox that follows is that the more you desire something but allow the opposite, the greater may be your chances of success.

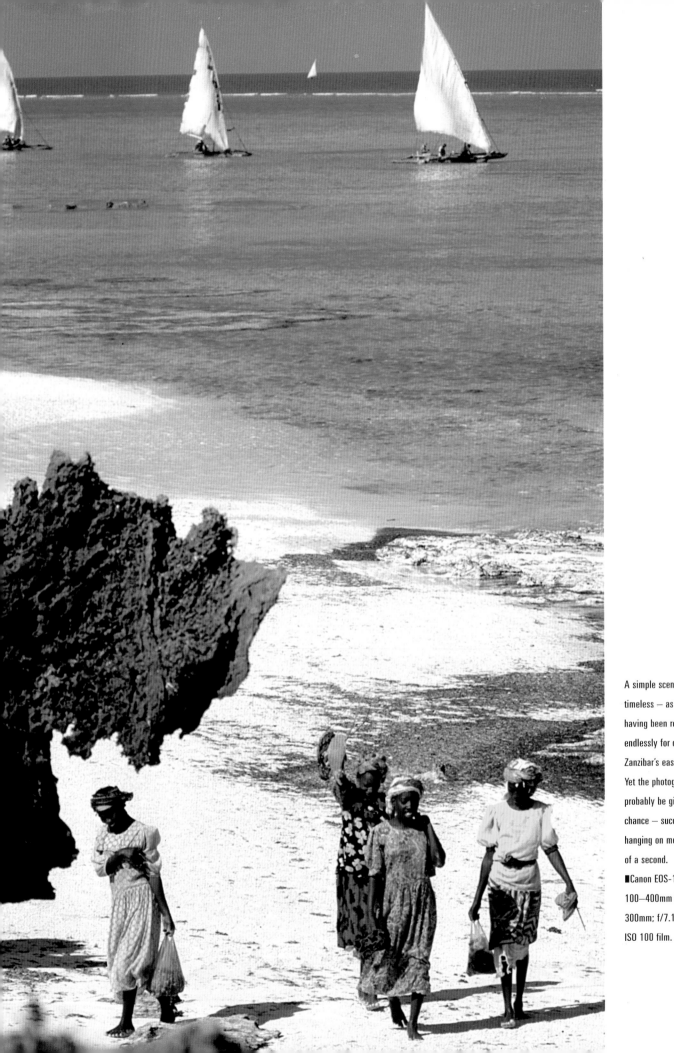

A simple scene that seems timeless — as indeed it is, having been repeated endlessly for centuries on Zanzibar's east coast. Yet the photographer will probably be given just one chance — success or failure hanging on mere fractions of a second.

■Canon EOS-1n with 100–400mm lens @ 300mm; f/7.1 at $^{1}/_{250}$ sec; ISO 100 film.

In terms of Tao, what is happening is the balancing of the forces of Yin and Yang – if you want total control, then it helps to lose control. Allow serendipity a role – if only a small one. Conversely, if your work relies entirely on the vagaries of good fortune, then you may have to assert some control even if it seems inappropriate. Great photographers, such as James Nachtwey or Sebastião Salgado, show how pictures can be strictly – even formally – composed and organized even when taken among the chaos of war and disaster. Others, such as Man Ray or Irving Penn, are so watchful of the entire environment while they work to control each element in the studio, that even the accidental appears to be part of their master plan.

One has also to accept that however much a photographer believes in going out into world with the film a blank tablet that is ready to have anything written on it, the fact is that the photographer is, at one stage of the recording process or another, hugely selective – even those photographers who expose several

"One does that which escapes one the most." Alberto Giacometti

rolls of film between getting out of bed and having breakfast. They are still, for example, exercising control over which brief fractions of a second from the whole time frame are to be recorded. Two rolls of film with each frame exposed at, say, $\frac{1}{60}$ second capture, in total, a little more than a single second of elapsed time. It is natural to conclude that photographers must learn to hone finely every aspect of the art – from technical control to aesthetic content – to refine

Left: At sundown, boys in Zanzibar like to take a dip in the sea and play football. The scene cried out for a "definitive shot" – one that held all elements together in perfect harmony. After several attempts, this seemed the most promising, but I become so excited the camera shook, and so the image is unsharp – despite it being taken with the assistance of an image-stabilized lens.
■Canon EOS-1n with 100–400mm lens @ 400mm; f/5.6 at $\frac{1}{125}$ sec; ISO 100 film.

every aspect of their thinking. This strategy, however, could not be more assured of failure. On the other hand, opening yourself to whatever life offers is not to be totally passive. Wise photographers deny themselves neither control nor accident, but allow both intervention and detachment. The Tao of photography is in the meandering between opposing strategies — like a river between its banks — out of which arises a richer photography.

Above: After a long, hot day I glimpsed out of the window of a rapidly moving car and heard a voice say to me, "Get out!." By the time I had returned to the spot, this little scene was playing itself out. It was then only a matter of waiting and watching, while fighting off feelings of tiredness. ■Canon EOS-1n with 80—200mm lens @ 135mm; f/4 at $1/125$ sec; ISO 100 film.

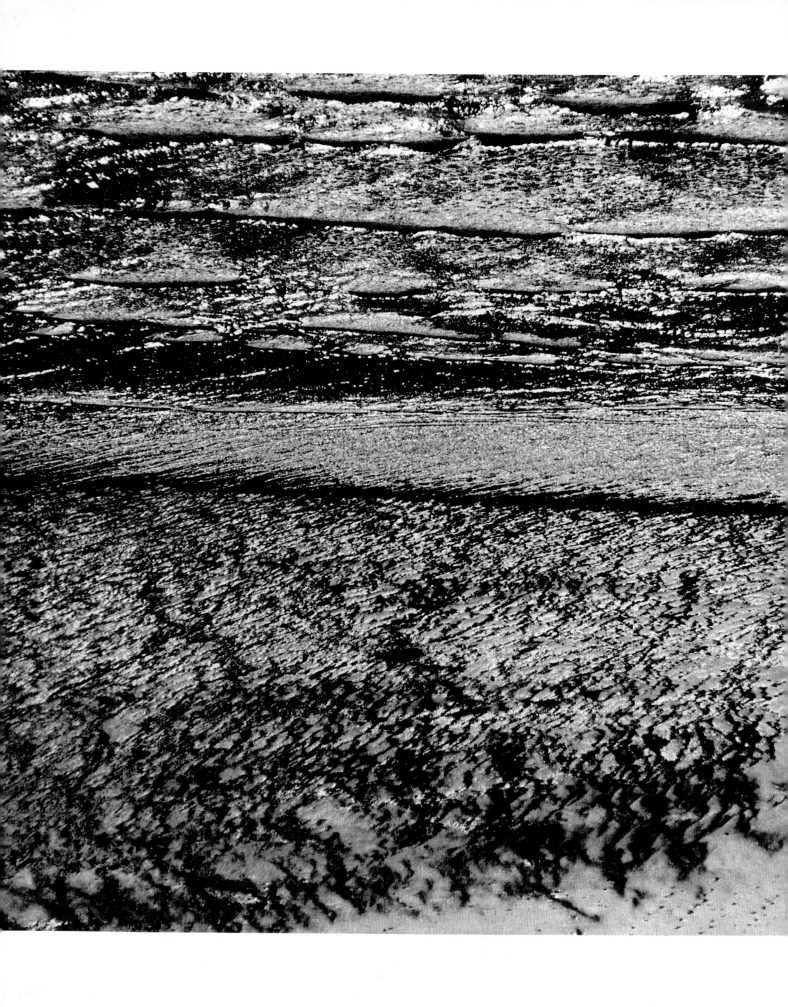

Approaching the Way

Photography is susceptible to technocratic obsessions . . . and the more so as digital imaging advances. Tainted thus, "technical" has become nearly synonymous with "mechanical." However, we all suspect that the most vital techniques are those that are essentially nonmechanical in nature. The Tao's attitude to photographic technique will be familiar to musicians, martial artists, and the like. First, Tao has no hesitation in accepting the tools as mechanical — necessary for making the work possible, but with their intrinsic weaknesses being inseparable from their strengths, and vice versa. "The sword that is too sharp," Lao Tzu observed, "will not last long."

Second, the technique of the wise is ever-present, but never evident. It is in everything you do and think, yet it is invisible and indivisible from your actions. Technique empowers the individual but it does not dominate. It must be learned and absorbed via a process of long training, but then best falls from consciousness.

The aim of technique is to produce fluency — an unbroken movement flowing from thought and conception through to production, and then on to visual consummation. This attentive thoughtlessness of a perfect technique is won only by hard work: the walking, walking . . . and walking some more, as Robert Doisneau advised; or by exposing rolls and more rolls of film, as Alfred Eisenstaedt insisted. And all the while we are reassured by Van Gogh's words: "If I shall be any good later on, then I am some good now."

Dance of light

It may be shocking to realize — particularly if you are a photographer — that we cannot see light itself. We may think that we are adding light through the use of electronic flash; we may also believe that we

"Photography must contain one thing: the humanity of the moment." Robert Frank

are shaping light by moving lamps around. But what we are really doing is only watching the effects of these changes to the light. Our knowledge of light is confined to observing the way things about us change the light and are, in turn, changed by it. Light is like air in this respect. We "see" air only because it rouses the waves to crash against the land, blows cold on our cheeks, causes the clouds to rush across the sky, or rustles the leaves in the branches of the tall trees. In a famous story told of Master Chuang Tzu, he commented on the happiness of fish as they swam and jumped in their watery world. Challenged on how he knew the fish to be happy, Chuang Tzu replied: "I know the joy of fishes in the river through my own joy in walking the same river."

Left: The famous Registan Square in Sammarkand, Uzbekistan, is usually presented as a somber monument, but a touch of winter sun and the joy of children playing in the snow helped bring the architecture to life. ■Canon EOS-1n with 24mm lens; f/5.6 at $^1/_{125}$ sec; ISO 100 film.

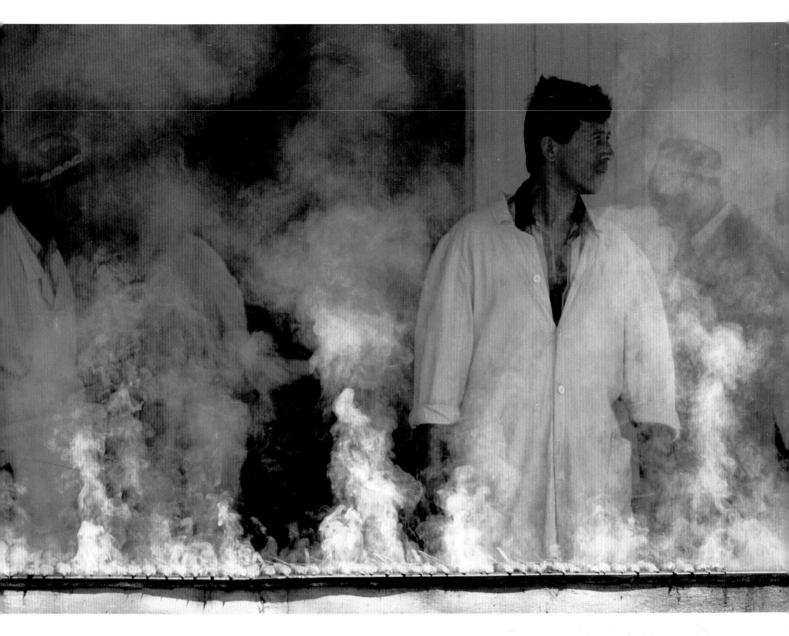

The joy and delight photographers take in their experience of light may, then, be a sharing of the experience of life itself. Our every photograph is a testament to that feeling — almost a prayer of thanks for the miracle of life-and-light.

It is our good fortune as photographers to have a particular awareness of light's harmony with life. The greater our feeling for it, the more richly it nourishes our lives and, in learning how to work with light, we may also attain a greater awareness of life itself. For the special conjunction of a certain quality of light with the stream

Above: The strong sunlight common in, for example, Uzbekistan, is often regarded as the enemy of color transparency film. However, the search for scenes in which the light partners a moment of humanity — rather than merely providing contrasty lighting — is always most rewarding. ∎Canon EOS-1n with 70—200mm lens @ 200mm; f/4 at $\frac{1}{250}$ sec; ISO 100 film.

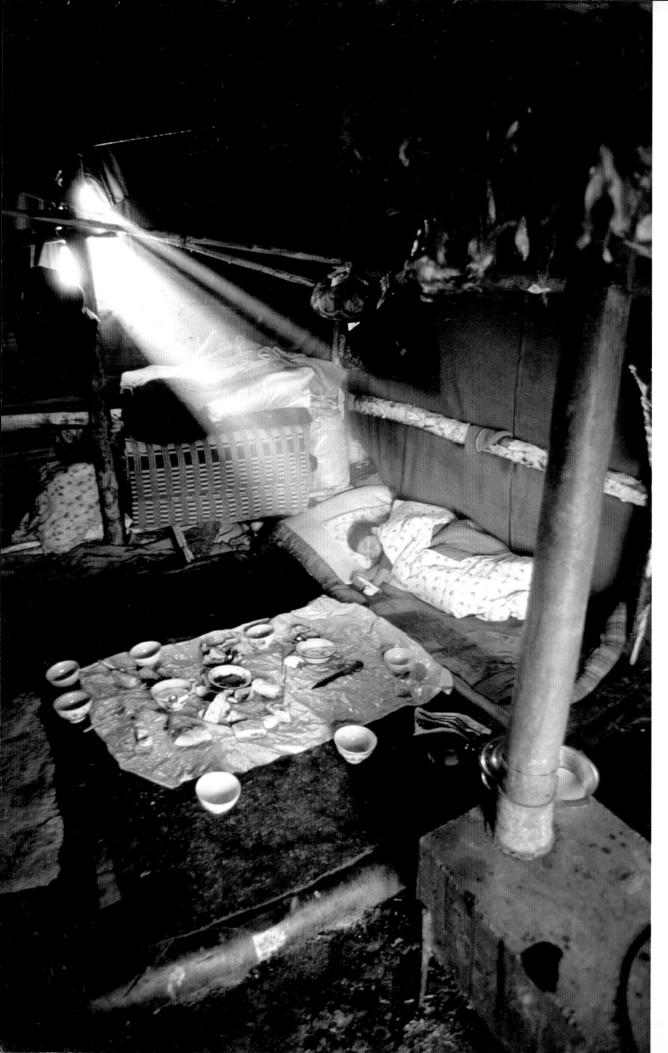

Left: Walking up a mountain valley in Kyrgyzstan we met shepherds who, without hesitation, invited us into their tent and supplied us with an impromptu but sumptuous tea party. As the afternoon sun dropped lower, it pierced the clear air and illuminated the tent. To the eye, the scene was all brilliant highlight and deep shadow, but the film and camera lens can "see" shadow colors the eye cannot register.
■Canon EOS-1n with 20mm lens; f/8 at ¼ sec; ISO 100 film.

of life that creates a significance or meaning that we turn into a photograph is, on each occasion that it occurs, a moment of creation – of a partial surrender to enlightenment. On some occasions we manage to get close to the full taste of revelation with our images, although sometimes, however, we fall far short of this goal. But no matter which, it is always light that leads the way.

"Art is a taste of enlightenment without the full experience." Rumi

To the Tao photographer, light is, therefore, not a force to be controlled, nor a thing to be mastered. Rather, the Way is to recognize that with light the illuminated and the illuminator depend on each other; and together they create a third – the entirety from which arises the significance. If light is the Yang – actively showing and revealing – the illuminated is Yin, in being in receipt of light, accepting its qualities, and then returning it to the viewer. Thus, the source, the subject, and the effect of the light on the subject are not separate entities but are, in fact, integrally all parts of the one thing, albeit seen from different positions. It follows, then, that a change of lighting is not merely a matter of switching off or moving a lamp to a new position, or waiting for the sun to appear. Rather, by working with the changing light, you also manipulate the subject itself. It is photography's job to track these shifting relationships and it is your task to understand their interplay.

Bear in mind that too much concentration on the mechanics of lighting is like watching your every hand movement in order to write: your handwriting inevitably becomes uneven and you dam the flow of ideas. Instead, the wise photographer learns to be taken up by light, not to contemplate it too deeply. The Tao of effective lighting is to let the subject and light work it out by themselves. Letting be: that is how to be effective without working.

Above: In Istanbul's airport, a momentary sunburst turns a prosaic interior into a temple of light. But you have to be not only quick – being constantly on the ready – you may also have to take risks with your security. Moments after taking this shot, an airport policeman was tapping on my shoulder. ■Canon EOS-1n with 20–70 lens @ 30mm; f/8 at ¼ sec; ISO 100 film.

Melody of the body

Above and opposite: Nude photography need not be confined to the clinical arena of the studio. Daily routines at home can yield images of an affectionate sensuality and unposed simplicity. The key is having good natural light indoors to work by and using full aperture for soft, impressionist tonalities. ■Mamiya 645 Pro TL with 80mm f/2.8 lens; f/2.8 at ¹⁄₁₅ sec; ISO 400 film.

"Sex and beauty are inseparable, like life and consciousness." D. H. Lawrence

It is usual to read about the beauty of form, the chiaroscuro of rounded shapes and smoothness of mass and light, and so on in the context of photographing the naked human body. Fine words certainly, but also largely a load of platitudinous euphemism. People photograph the nude and enjoy looking at nude photographs because of the enjoyment of the erotic feelings and the stimulation of their sensual and sexual imagination these activities engender.

For the Tao photographer, to deny the erotic content of nude imagery is not only dishonest, it also removes the possibility of having respect for the subject – and it is this denial that is essentially the source of the exploitative and prurient aspects of photographing the naked figure. To Tao, acknowledgment of the sexual and the erotic in the nude gathers naturally the balancing forces of awe for the beauty, respect for the person, and responsibility for the representation. For if the former is Yang in its force of feeling and vigour, it calls for the receptive and protective Yin forces as a counter. Alternatively, if the sexual defines the Yang dimension, then the softer, aesthetic values are Yin. Now, nobody demands that each picture be perfectly balanced, but wise photographers flow between the Yin and Yang, sometimes favouring one side, sometimes the other, and simultaneously bridging them in their work.

The art of nude photography is, arguably, the working through of this balance – a balance that results from the composition of light and dark masses, the contrast between clothed and unclothed, between the texture of skin against that of other surfaces, and so on. Or you could investigate the balance between abstract forms,

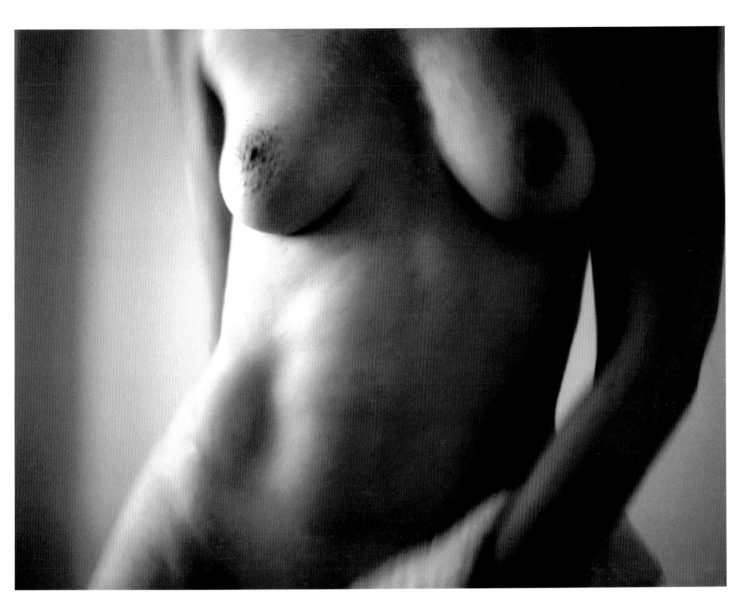

which are almost visual puzzles in their redirection of the gaze, forcing a viewer to sort the tangle into its constituent parts.

The history of photography has shown that any approach can yield effective results – ultra-wide lenses to ultra-telephoto lenses, the finest film to the coarsest-grained types, even a distorting mirror and manipulation of the fragile layer of emulsion. If, however, there is any single thread running through all the work, it is the need to subdue lighting contrast. It can almost never be too soft and is all too easily over-contrasty – a state that masks the smooth gradations that are a chief joy of photographing the human body.

"The body says what words cannot." Martha Graham

Nude Workshop

When we concentrate on the texture and the glowing smoothness of skin's tonal transitions, we are asking much of silver-based materials: careful exposure and development control are required. The corollary is that this is extremely demanding on the capabilities of digital technology. Normal 24-bit color (the usual working bit-depth of software such as Photoshop) is not sufficiently highly resolved to present accurately the very gradual tonal transitions of the body. The result is posterization: smooth blends are reproduced as relatively abrupt changes of tone. When you scan color transparencies featuring nude subjects, you are best advised to set your scanner to the greatest bit depth. If your scanner offers 36-bit or even 48-bit color, then use it, gratefully.

Many pictures of the naked body depend for their success on the quality of the out-of-focus image. Not surprisingly, it is only good-quality lenses that produce good quality when the image is out of focus. Classic optics, such as the Nikon 105mm f/2.5, Planar 80mm f/2.8, and Leica 80mm f/1.4 lenses, are marvelously sharp as well as superbly unsharp. But it cannot be stressed enough that the human form is so familiar, written so strongly across our psyche, that virtually any photographic apparatus can be turned to depict it and to create a feeling and sensitive image.

Above: My model and I needed to work at a brisk pace for this series of nude studies because the best light for the room came from a dawn sun which lasted less than half an hour. By using a zoom lens, bracketing each shot, and changing focus from the body to the mosquito net and back again — without thinking too much — I hoped to produce a good variety of photographs.

"Beauty is . . . the passionate and positive expression of the complete self." Vidal Sassoon

Left: Part of photography's magic is its ability to press-gang something as functional as a mosquito net into a role far from that intended by its makers. The blue coloring of the net immediately suggested itself to me as potentially an ideal background for photography, but it was a few days before the combination of ambient light and awareness was resolved into a rich series of nude photographs. ■Canon EOS-1n with 17–35mm lens @ 35mm; f/5.6 at ¹/₃₀ sec; ISO 100 film.

Seeing eye to eye

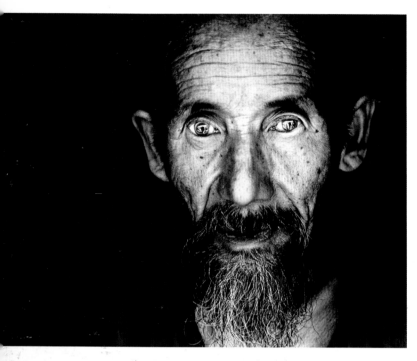

Above and opposite: For a series of portraits taken in China, I decided to work very close to people, requiring a face-to-face approach — which meant I had to be trusted to enter the strangers' personal space. Often, the most poignant photographs are those in which the eyes speak of suffering, of a hard life — such as those of the woodcarver, above, almost blind with cataracts, and the thresher-girl, opposite, working in stifling heat. ∎Leica R-4 with 60mm lens; f/4 at $^1\!/_{250}$ sec; ISO 400 film (exposed at EI 320).

"I am only stimulated by people, never by ideas." Richard Avedon

We talk of "taking someone's portrait", of "recording a sitter's features", and we may even endeavour to "get capture something of a person's character". For the Tao photographer, the instinct is to suspect this to be a rather one-sided and, therefore, an incomplete approach to portraiture. If the active part of portraiture, the Yang element, is the recording of the features, what then is the Yin counterpart? At one level, the photographic equipment is Yin: it receives and retains the image. At another level, it is the sitter himself or herself who is Yin, for it is that person who is receiving the attention, responding to instructions; it is that person who is being photographed. Therefore, portraiture, fully understood, encompasses the whole relationship between the photographer and the photographed. Seen from this perspective, when we talk about "taking a person's features", we mean, in effect, "recording the features of the relationship".

At the same time, we prefer certain types of relationships over and above others, according to the context or communicative task we have. In portraits of leaders of industry, for example, we expect to perceive a different relationship from those in portraits of close friends and family. When taking photographs on our travels, we generally prefer not to photograph embarrassment or anger in the strangers we meet.

The photographer who wishes to make a portrait would be wise, therefore, to develop the personal relationship first: you are, after all, not about to approach a tea pot. The most successful portrait photographers learn a good deal about their sitters before they ever meet, spend time getting to know them better, and indeed

often end up becoming firm friends. Great portrait photographers, such as Yousuf Karsh or Steve McCurry, love people and are adored by their subjects in return.

It should now be clear how to approach taking photographic portraits of strangers you meet on your travels. If you sneak a picture of somebody you will record the exploitative, intrusive nature of your relationship with them. If they are timid or unfriendly toward you, then your portrait depicts both the person's lack of poise as well as their physical features. Generally we prefer to

"Unless your heart is open and serene, how can you respond completely?" **Master Foyan**

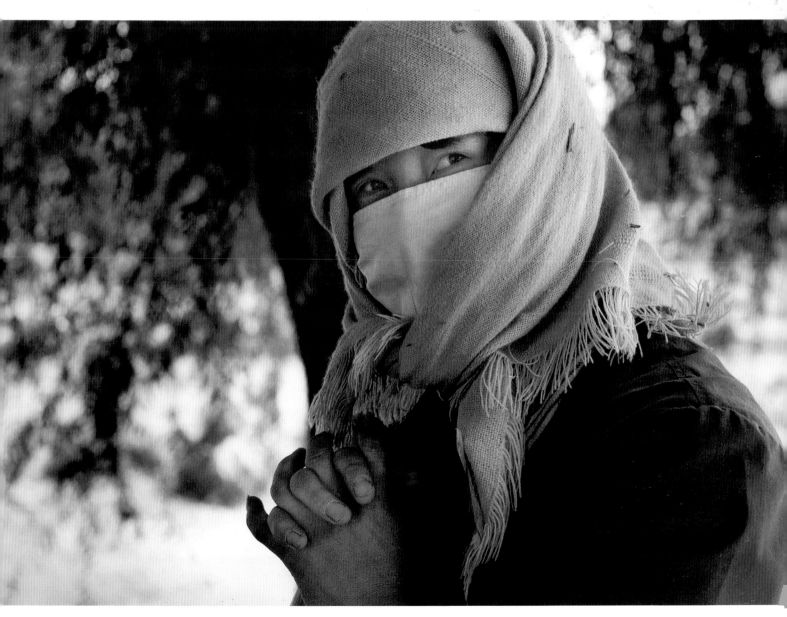

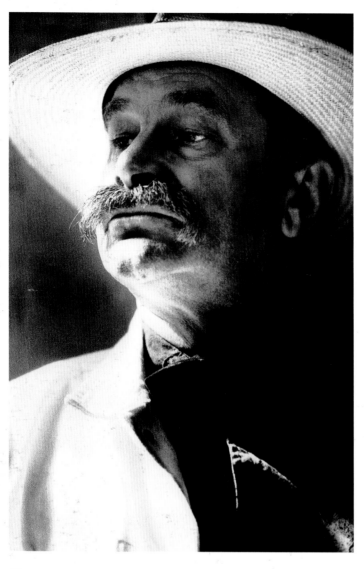

obtain a portrait that is somehow as true of the person as possible. But contrary to the notion that you should be invisible, "a fly on the wall," in order to avoid influencing your subject, you actually end up approaching more closely to that person by making a whole-hearted and open approach. You try to create a friendship – however brief – that is sincerely based on trust and respect. You then realize that since there is no way the person can fail to be influenced by the presence of the camera, the only way your subject can feel and act as normal is when that person feels completely safe and at ease, as when among friends and the familiar.

By this point, you should be well on your way to forgetting completely the often-repeated advice to photographers to take portraits by using a moderately long focal length for your camera format – say, 85 to 105mm for 35mm-format cameras, or 150 to 180mm for 6 x 6cm (2¼ x 2¼in) format cameras. Photographers working in harmony with Tao do not choose a lens; instead they work on the assumption that the entire system – encompassing the subject and photographer, as well as the purpose of the photography – will determine which lens is to be used. You can take excellent portraits with an ultra-wide-angle lens as well as with a super-telephoto optic, although it must be admitted you may need more skill and experience to use these extreme lenses than the so-called moderately specified "portrait" lenses.

The wise photographer disappears by being evident, for that is the best way to melt into the background of the familiar. To photograph people, you cannot help including your subjects' lives in and around the time you encounter them – and that must include you, the photographer. Therefore, it is wise to realize that a portrait is more than a depiction of a face – it is a record of an act of personal relating.

Above: For a commissioned portrait photograph of the writer Ken Smith, which was to be used for a book jacket, it seemed appropriate to photograph him from a distance using a long lens. ∎Olympus OM-2n with 200mm lens; f/4 at ¹⁄₂₅₀ sec; ISO 400 film.

"A velvet hand, a hawk's eye – these we should all have." Henri Cartier-Bresson

Right: Sitting in unaffected elegance in the light of a setting sun, this Zanzibari boy was waiting for his parents. A smile to him and a request, in their own language, to his parents was needed even before raising the camera. The request could have ruined the moment, but I prefer taking that chance to the far greater risk of not asking at all.
■Canon EOS-500N with 28–70mm lens @ 70mm; f/4 at $\frac{1}{250}$ sec; ISO 400 film.

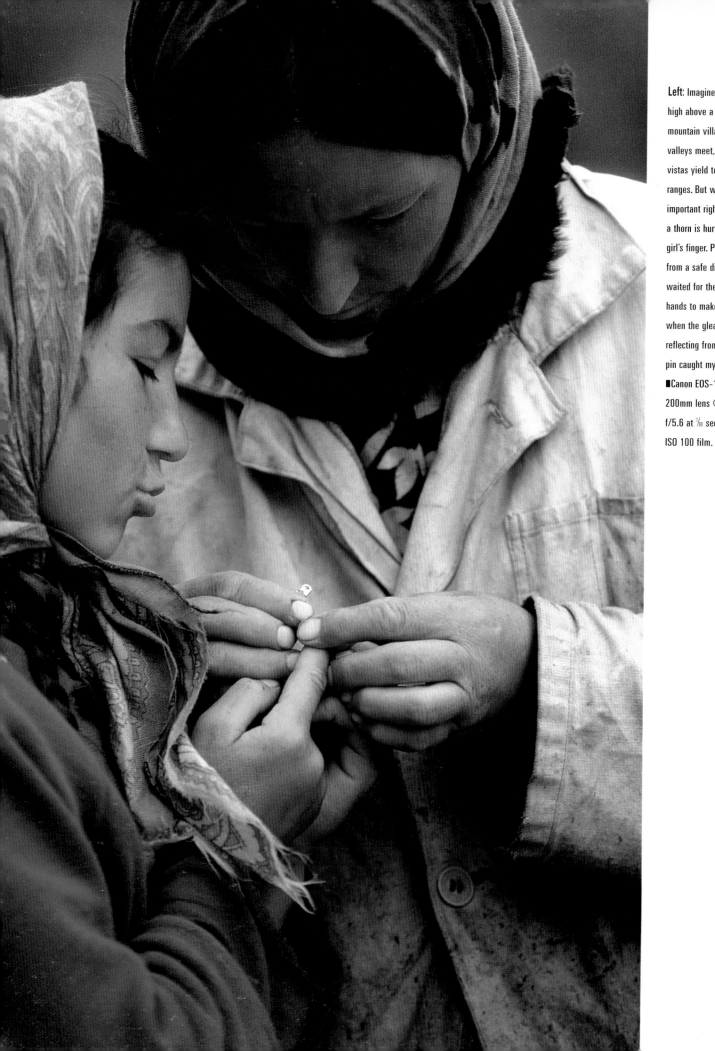

Left: Imagine the scene: high above a pretty mountain village where two valleys meet, magnificent vistas yield to distant ranges. But what is really important right now is that a thorn is hurting the little girl's finger. Photographing from a safe distance, I waited for the eloquence of hands to make the image, when the gleam of light reflecting from the safety pin caught my eye.
■Canon EOS-1n with 80–200mm lens @ 180mm; f/5.6 at 1/60 sec; ISO 100 film.

Working with hands

Tao holds that everything is interconnected, that in each and every segment of the universe you can see something of the rest of the universe. But there is also no doubt that it is easier to see a world in some grains of sand than it is in others. Nonetheless, grounded on this interconnectedness is photography's ability to transform a picture of a corner of a building into an image that tells you about the whole architectural complex. In a similar fashion, a tightly framed close-up of a few plants can tell you more about a forest than an overview of the whole terrain. It is how the edge of a fashion item can tell you about the entire culture that produced it. With the human form, too, the history of photography has demonstrated that just about any part of the body can speak at length of the rest.

Personally, I have always found people's hands to be almost more fascinating, and at times more telling, than their faces. In the most revealing way, written into somebody's hand is the history of that person's life. There is that terrible moment in the play by the nineteenth-century Russian dramatist Nikolai Vasilyevich Gogol, *The Inspector-General*, when a wealthy gentleman, trapped with a group of peasants, tries to conceal his origins. But the peasants make him turn over his hands. "A baby's bottom: never done a day's work in his life" they conclude, scornfully.

From moment to moment, hands can tell you much: elegant hands belonging to a beauty may be tight, clenched, and very nervous – the signs of a lack of confidence lurking beneath a glossy exterior. In as much as they are revealing, when you look for people's hands you will see that they are often concealed. In fact, I have

"The Wise boldly pick up a truth the moment they hear it." Master Xue Dou

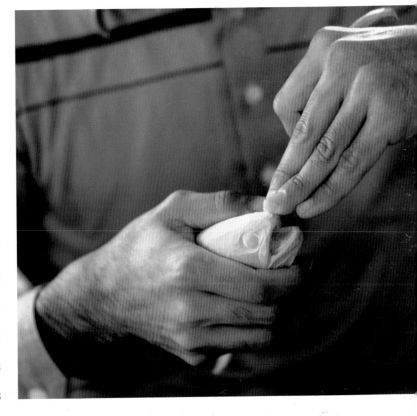

Above: The hands of a sculptor, one of the Ainu people of Japan, carves a leaping salmon, which — as they do all animals — his people hold in reverence. ■Canon EOS-1n with 70–200mm lens @ 135mm; f/3.5 at $1/125$ sec; ISO 100 film.

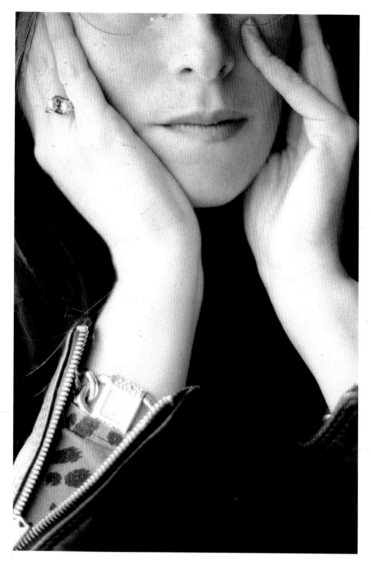

Left: It is safe to say that no portrait photograph suffers from revealing the sitter's hands, and sometimes the hands can say more than the face itself. Here, the hands lead up to and frame the face and to reveal any more would simply be superfluous to the image.
■Nikon F-700 with 80–180mm f/3.5–4.5 lens @ 150mm; f/4.5 at $\frac{1}{125}$ sec; ISO 400 film.

found that people are more nervous about having their hands photographed than their faces. On the whole it is easier to get close to a face, even that of a stranger, than it is to their hands. Yet hands are worthy of close attention, rather than being regarded as merely accessories to the larger portrait. Often, even the oldest, most stressed hands are wonderfully beautiful, while those of a young person can be utterly sensual. But over and above these considerations, the shapes hands make are naturally rhythmic, repetitive in nature yet never in a strict pattern. And I have seen eloquently elegant hands, even when distorted or malformed.

The photography of hands, however, brings the usual problems of working in close-up. Depth of field is limited, so you have to choose between substantial parts of the image being out of focus or using a long exposure to compensate for the small aperture required to maximize depth of field. However, fingers are constantly on the move: people who are otherwise still can send all their body movement into their hands. Fingers at work can be even worse. Focusing on them, even with the benefit of modern autofocus lenses, is nearly impossible and only electronic flash can stop their flight.

You need to consider focal length in relation to the subject with care. A very short lens may distort too much, while a longer one will enlarge the subject but at the cost of losing the feeling of closeness

"When I have won a victory, I do not repeat my tactics but respond to circumstances in an infinite variety of ways." Sun Tzu

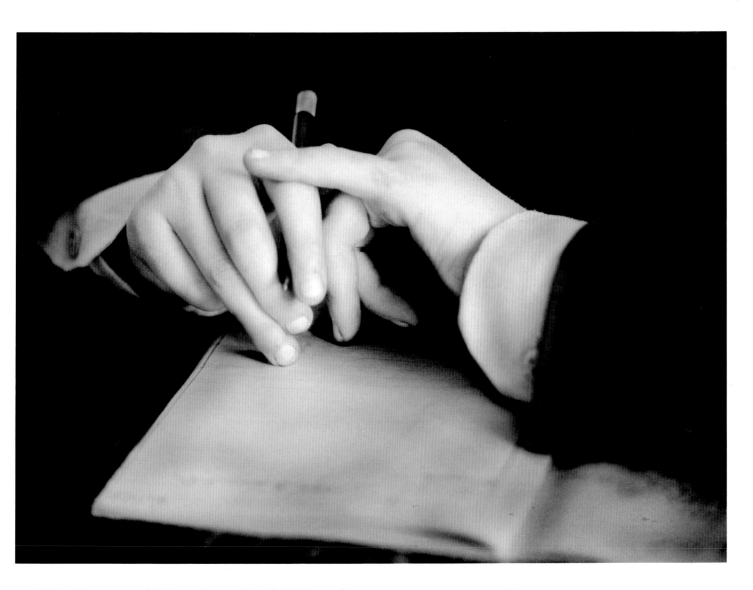

needed to give a sense of intimacy. A normal or slightly longer lens works well, allowing greater working distance. Digital cameras can also give good results, with almost all types offering close-up capabilities. However, the disadvantage of going the digital route lies mainly in "shutter-lag" – the time interval between pressing the shutter and the image being recorded – being long when compared with that of a conventional camera, so you may end up missing the exact timing of the shot.

Nonetheless, in these difficulties the alert photographer will hear a clue – as the universe does not give up its secrets without a struggle, neither do treasures lie out in the open.

Above: On a tour of a school in Romania, our arrival in a classroom would invariably cause suppressed pandemonium (the children were generally all very well disciplined). However, one boy seemed to be quite unperturbed by all the excitement and, as you can see, his hands confirmed it. ∎Canon F-1n with 135mm lens; f/2 at ¹⁄₆₀ sec; ISO 400 film.

Calligraphy of the leaf

It is easy to be blind to the commonplace, to what you see every day. Rather like the air we need for our physical well-being, we rely on plant life for our continuing mental balance and health – but we notice it only when it is missing. We think about our furniture only when somebody has moved it without our permission.

It takes, then, a certain poetic concentration to transcend the normally inconsequential, to lift the invisible, the ignored, into

"I want to transform reality with a poetic conception . . ." Ernst Haas

the realm of the observed. It is only through an act of focused imagination that meaning is revealed. In fact, there is probably a photograph in the next shrub you pass. An image can be extracted from any blade of grass you step on.

The gap between a picture and plant life is bridged by your imagination and artistic force. To paraphrase Kahlil Gibran: "You and the Leaf are one. There is a difference only in heartbeats." Karl Blossfeldt – who spent a lifetime studying plants in monumental detail – echoes this feeling. As he says, plants are themselves works of art, created by a life ". . . impelling everything with elemental force to the highest artistic form".

Besides being present everywhere, and being an inexhaustibly patient subject, plants offer the advantage that you can approach them with just about any type of equipment – from a digital or conventional snapshot camera to a large-format studio camera.

Nonetheless, cameras that have a good close-focusing ability are the most versatile. Those with built-in focusing extension rails, such as the Rolleiflex SL66 and Mamiya RB67, are perfect, as are any of the SLR models to which you can attach focusing bellows. A zoom lens equipped with a good-quality close-up supplementary lens is also a versatile option – in fact, you can improve the close-up performance of most lenses by attaching close-up lenses. Plants in the open will move in the slightest breeze, so it is best to wait for calm days. Using on-camera flash is seldom a solution to the problem of avoiding subject movement, since it usually destroys the quality of the light and shadow of natural illumination. And you can use fine-grained or coarse-grained film, colour or black and white – since you are working with elemental shapes, it little matters technically how you approach them.

Lenses with normal-to-long focal lengths are easiest to use, but you can offer variety by using moderately wide-angle or very long lenses close-up. An alternative, suitable also for wide-angle lenses,

" . . . You do not have to go outside to see Heaven. The more you travel, the less you know." Tao Te Ching

is an extension ring, which increases the distance between lens and camera. However, image quality may suffer. Technically, the chief issue is the tension between the loss of depth of field you experience as you approach the subject more closely and the way

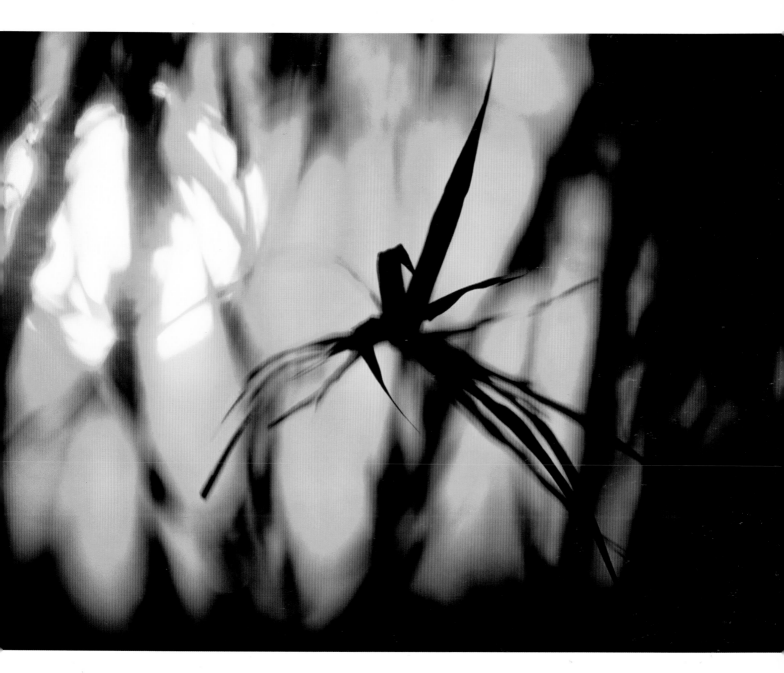

Above: The basic fact that this is a picture of grasses taken at sunset in the savannah of Namibia hides another fact: the scene is all but invisible to the unaided eye. It was taken with an ultra- telephoto lens set at full aperture. Therefore, the image is the product of light and grass interacting with the photographic process — not only the optics, but also the tonal qualities of the film. Even the colour is not "accurate"— to the eye, it was a bleary yellow, not this rich orange. ■Canon F-1n with 300mm lens; f/2.8 at $\frac{1}{250}$ sec; ISO 100 film.

Right: In search of a berry in Fiji, said to be able to cure cancer, I found myself more interested in the way the light "wrote" patterns with the lush vegetation. A super-wide-angle view distorts the perspective but it also gives a sense of being in with the plants. ■Canon EOS-1n with 17–35mm lens @ 17mm; f/5.6 at ¹/₃₀ sec; ISO 100 film.

in which plants take up depth in space. At the same time, the reason plants translate so successfully into the photograph is that their outlines have an essentially two-dimensional quality, which is, in essence, calligraphic. As a photographer, your task often resolves into how to control the balance of unsharpness and sharpness through a choice of lens aperture and careful focusing.

And as you work with the shapes of the leaves, you simultaneously work with the non-leaf – the gaps, the shadows, the lights. The composition is born from the artistry with which you work with shape and non-shape, leaf and branch, or air and space. The concentration and intensity of vision you need is as much as that required for a portrait session or for recording a street demonstration. To the Tao photographer, no world is too small, no detail too minor to merit the utmost intensity of inner attention.

The open and relaxed nature of working with plants means you can experiment, meditate, observe, and generally spend as much time as you want allowing your imagination to wander where it pleases. The tangle of lifeforms will dance before your mind with meanings just beyond revelation. As you concentrate more and more on such subjects, you may discover that there is no clear water between meditation and photography.

Water music

Water is a beloved metaphor and symbol in Taoist writings, but water is also a tough one for the photographer thanks to the very contradiction inherent in the medium. The reason why water is so potent a symbol is the beauty of its flow and movement, yet photography must hold it still if it is to depict it at all.

"Yin and Yang produce a circular evolution in which every end is a beginning." Tai Gong Diao

At its most interesting, water is usually moving rapidly, often in hollows illuminated only by dim light where it is at its most difficult to photograph. Another feature, also much appreciated in Tao, is that water always finds its own level. Therefore, when still, water always presents a flat surface to the photographer. However, it is one that is usually appears inclined to the camera, so it is difficult to reproduce the visual experience of water – a continuum of clarity of light and tone – because the normal camera lens cannot provide sufficient depth of field, even at minimum aperture.

To some degree, water's beauty is dependent on its surroundings. We love to see the reflections of mountains in the fluid surface of a lake, for example, or the sails of a boat shimmering on a still sea. But water does not reflect perfectly. In the act of receiving the light, it interprets and modulates the incident light falling on its surface before returning it as a reflected image. Thus, while water appears to be archetypally Yin in character – it

receives, it accepts – water is essentially Yang when it reflects light because it imposes its own character and mood on the reflection.

So water can be seen as a metaphor for the photographic process itself – the camera and film receive light in a similarly passive way, but before they return it as a photograph, both the equipment and the process manipulate the light and imbue it with a unique character. The photographer is then to the photograph as the weather is to water. By controlling the character of the water – mirror-flat or whipped up into a storm – the weather exercises complete control over the image in the water. In this way, the Tao photographer can learn from the nature of water the nature of photography itself. In the same way that water is not an imperfect mirror, but rather a live interpretation of its surroundings, so photography is not an imperfect record, but a continual, conscious appraisal of all that passes before its surface.

Quite apart from the technical challenge of recording water – as an animate thing constantly playing with light, reflecting and modulating it – water is also a great visual challenge. The slightest change in viewpoint can make a vast difference to what you see. Even the slight loss of height in perspective when you raise an SLR

Right: Sometimes by simply arriving at a scene you can disrupt the air and so destroy patterns made between the water and its surroundings. Here, I had to wait several minutes for the blades of grass to settle after my arrival had disturbed them. Even so, it needed several shots to capture the pattern. ■Nikon F2 with 135mm lens; f/5.6 at $\frac{1}{60}$ sec; ISO 400 film.

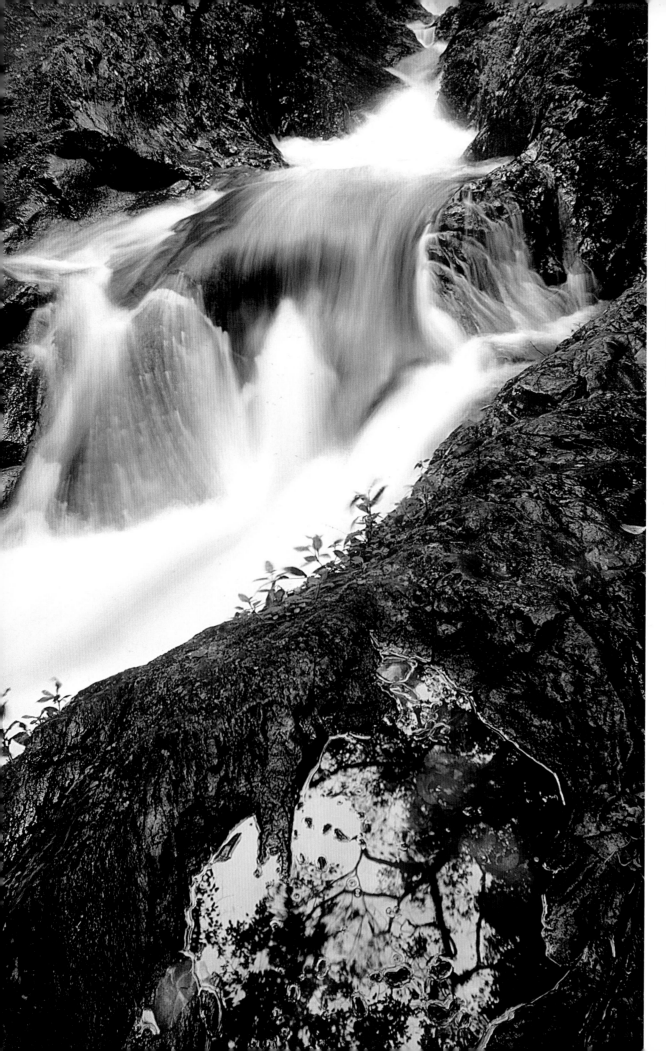

Left: Swollen with water after recent heavy rains, this gully in Fiji is a favorite place for swimmers to slide down headfirst. But all I was interested in was an image of the still little pool in the foreground against the rushing waters. I used a tilt lens to adjust the plane of best focus so that it took in both the pool and the whole length of the waterfalls. ■Canon EOS-1n with 24mm lens; f/11 at 1 sec; ISO 100 film.

camera to taking position (the camera lens is lower than your eyes) can cause a significant change in picture composition. And the slightest change in exposure can intensify color and reveal hues that were simply not apparent to the eye at the time of shooting. Because of this, it is always worthwhile bracketing exposures whenever you photograph water.

The Tao photographer delights in this subtlety (though with momentary lapses of wisdom, it can be very frustrating, too) – the great leaping changes resulting from minuscule shifts in viewpoint show that everything is profoundly interconnected. Cause and effect ripple far beyond the immediate: to the wise, the slightest is what is obvious. A Tao photographer hones perception, learning to savor that which has no taste, learning to treat the large as the insubstantial and the small as the substantial.

You can tackle the problem of water's rapid movement in two ways. First, you can attempt to use a shutter time that is brief enough to stop its movement, but this often defeats your attempt to record the visual experience of its flow. Or, second, you can use a long shutter time (with the camera steadied on a tripod) so that the water records on the film as a blur. The longer the shutter remains open, the more blurred and white will the water appear, but if the exposure is too long, the blurring becomes overly even and so lacks texture. To catch falling drops of water and splashing, shutter times need to be ¹⁄₂₅₀ second or shorter. With times extending into whole seconds, water is turned into a smooth sheet of blur. Take care that the whiteness of the foam does not become formless and empty – symbolic, perhaps, but visually often not convincing.

The problem of the inclined plane of water's flatness is more difficult to overcome. Unless you have a camera fitted with a tilting lens panel, you must resort to setting the smallest practicable

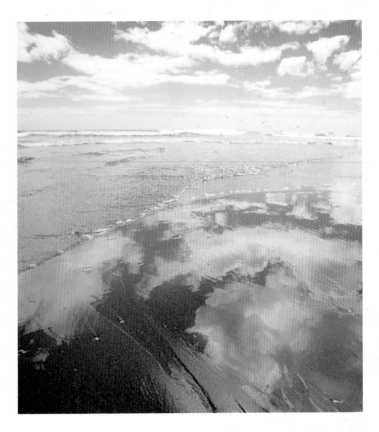

Above: Water soaking through the sand at low tide in New Zealand creates a mirror-like surface reflecting sky and clouds. Originally a greater portion of the scene was shot, but this cropping emphasizes an unbroken canvas of sky and cloud.
■Canon EOS-1n with 17–35mm lens @ 17mm; f/11 at ¹⁄₆₀ sec; ISO 100 film.

aperture in order to give you the necessary depth of field. Note that, generally, it is best to avoid using the very smallest aperture available on a lens, since optical quality usually falls drastically at apertures of f/16 or f/22 with 35mm-format lenses.

The tilting control (available, for example, on Canon TS-E lenses of 24mm, 45mm, and 90mm focal lengths) gives you the option of angling the lens or film plane to allow the inclined plane of the water, the film plane, as well as the plane cutting across the lens axis to meet on a single line. When achieved, you have satisfied the Scheimpflug condition, which results in the whole of the inclined plane being rendered sharp, even with the lens set to full aperture.

Patterns of chaos

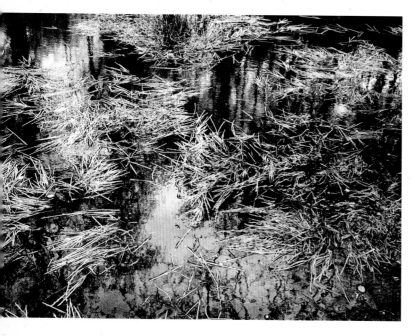

Above: I had passed this muddy, inglorious, and unpromising puddle several times over a period of several hours before something made me step back and look more closely at it. Whatever the reason for the realignment of my vision, a photograph was made where only a forgotten glimpse might otherwise have been. ∎Leica M6 with 35mm lens; f/8 at ⅓₀ sec; ISO 400 film.

Opposite: A loose fitting on a tripod caused the exposures being made on a simple box camera to move about, producing this interpretation of a garden. ∎Kodak Box Brownie; ISO 32 film.

"At the foundation of everything is Nature." Lao Tzu

It is tempting to claim that for Tao, there is no chaos — merely different degrees of order. But Taoist thinking evolved against a background of great turmoil, the "Warring States Period" of Chinese history, and offered intellectuals of the time the solace that beyond the chaos of their lives there was peace and good sense. In modern times, however, chaos has taken on a kind of respectability thanks to scientific theories about the unpredictability of complicated systems — small variations in large systems can make it difficult to predict outcomes. It suggests that Man playing God is impossible — indeed, according to some theories, perhaps even God cannot play God. The debate is Tao all over again: it is natural for the Yang of good order and stability to be countered by the Yin of disorder; elevating flakiness to a universal necessity.

The tension between the two attitudes is obvious in photography. If you photograph a mess, your photograph will be a mess. Yet chaotic situations are, paradoxically, among the richest for photographers. Disorder can be returned to order in the viewfinder. At the end of the Second World War, photographers entering concentration camps with the liberating troops were deeply perturbed to find themselves carefully composing pictures of the dead. Even now, photojournalists struggle in their hearts with the beautifully composed photographs they almost instinctively search for when working in war regions.

At the same time, as photographers we delight in being able to see what others cannot: charm in an otherwise meaningless scattering of paper or a milling crowd of people that resolves itself, momentarily, into a miraculous pattern of color and rhythm.

This has much to do with the way our brains are wired. Presented with a scattering of things, our eyes appear to search for pattern. In fact, they are programmed to respond strongly where things can be fitted into a pattern. This means that seeing patterns or regularity is an innate ability that can be developed by training.

The chaos that catches your eye is almost certainly not entirely random, nor is it often the first glimpse from which the photograph arises. You will need to walk around it, to look closely. In short, you may have to meditate on it before it will unlock itself and yield its picture to you. Thus, the Tao photographer responds to life – walking the Middle Way between chaos and regularity, equally avoiding pattern as well as jumble.

"A singing line and sensuous beauty . . . are not the sole sources of bliss." Alfred Brendel

Opposite: A change of optical power with focused distance (image size changes with focus) produced this effect. ■Mamiya C330 with 80mm lens; (exposure details not recorded); ISO 125 film.

Below: I experimented with cutting up and pasting together many similar photographs of water. This gave me a sizable mosaic, which, although composed of individual images, made up a larger totality. This work calls for great precision, painstaking assembly, and a long gestation period. ■Leica M6 with 35mm lens; f/5.6 at $\frac{1}{60}$ sec; ISO 200 film.

Artifacts and fiction

Watching young photographers at work in the studio, one thing above all strikes me time and again. It is how those with superb, 20/20 vision can be so blind, so oblivious to their subject – even as they are meant to be photographing it. One photographer will decide that a light needs to be moved in order to improve the shadows – that is indeed correct, but he turns his back to the set-up as he makes the adjustment. Another decides that the perspective is not working and so goes to move the camera, but instead of watching what effect the change brings about, simply hauls the tripod-mounted camera from place to place.

The Tao photographer is constantly aware – eye, heart, and mind ever watchful for the significant – of the coming together of meaning that results from light illuminating a form. The momentary transcendence of the "nothing at all" into a realm of poetry in art reveals itself only to the observant.

This watchfulness is not consuming or tiring; it is simply a state of being. For example, a musician will instantly notice if somebody begins to sing in the street – even among the city's noise, distractions and hubbub – but this does not mean that the ears of the musician are constantly strained. Most people will notice someone strikingly beautiful passing in the street, yet we are not consciously looking out for such a person.

The beauty of being open to the ordinary is that the resulting photography is accessible and easy – all you have to do is carry a camera around with you at all times. In fact, the very presence of the camera in your bag or pocket can alter – indeed heighten – your

Opposite: Pieces of paper rescued from the wastebin were arranged until something was articulated. The print was made on printing-out paper, which explains the golden tone. ∎Linhof Master Technika with 150mm f/5.6 lens; f/11 at 2 sec; ISO 125 film.

Above: A mobile constantly offers images for the taking. ∎Rolleiflex SL66 with 50mm f/4 lens; f/8 at ⅛ sec; ISO 400 film.

"The Wise enjoy nothing in particular, and so enjoy everything in general." Tao Te Ching

Above: While clearing out the garden at the end of summer, I threw unwanted material into a heap . . . and a heap they remained until a late period of sun brought the jumble of shapes and colors to life. The gardening was instantly forgotten in the dash for a camera.
■Pentax MZ-5 with 43mm lens; f/5.6 at $\frac{1}{60}$ sec; ISO 100 film (exposed at EI 200).

awareness. A compact, autofocus camera with a retracting zoom lens of modest specifications – for example, somewhere in the range 35–70mm – is slim and easily pocketable, particularly if it is a small digital model or an APS-format camera. Often a scene holds out promise, but it is in the small detail that you can mine most rewardingly. So you will need to use a camera that can focus quite close-up, and in this respect digital cameras generally offer far superior results when compared with autofocus compacts.

There is no great secret, for the key is simply to be receptive. To be filled, one must be empty; to take, one must be open. The receptive photographer sees no more than others; the difference is in the movement toward the perception. When you move closer (if

only in your mind), you will find the image meets you halfway. It is as if a conversation or exchange can then commence. You greet the perception and get to know it. Figuratively, you walk around each other, so that while you are checking it out, it is evaluating you. And if you like each other, an image is in the making. It could be a layer of oil floating on water, cigarette stubs in an ashtray, a pile of stones in the street, a tangle of discarded plants, or splashes of paint on a wall. When you take notice of your perception, it speaks out and perhaps you will understand the language — in giving it attention, it returns with meaning. And if not, you will go on your way. Then the scene will settle itself down again, quietly awaiting another perceptive person to engage with it.

This interchange between the perception and the perceiver can take place both with the object found by accident as well as during the construction of a controlled studio set-up. Without a continually sustained awareness, nobody can successfully work in the studio.

As anyone knows who has organized a complicated production or expedition, the most meticulous and thorough planning covers, at best, only about half of the eventualities. That is not to advocate that you do not plan: rather, that in order to make the most of the Yang of controlled execution there is nothing better than a smattering of the Yin of disorder and unplanned happenstance.

The Tao approach to acquire therefore goes well beyond merely the acceptance of the unwelcome eventuality; it is to be constantly prepared to welcome the unexpected.

"Well, I enormously enjoyed doing this interior of nothing at all." Vincent Van Gogh

Below: With idyllic views of the Indian Ocean beyond, it seems perverse to photograph the room's mosquito net. But why not? If you have no inhibitions, then images will have no hesitation in presenting themselves to you.
■Canon EOS-1n with 17–35mm lens @ 20mm; f/8 at $\frac{1}{60}$ sec; ISO 100 film.

Transcending space and time

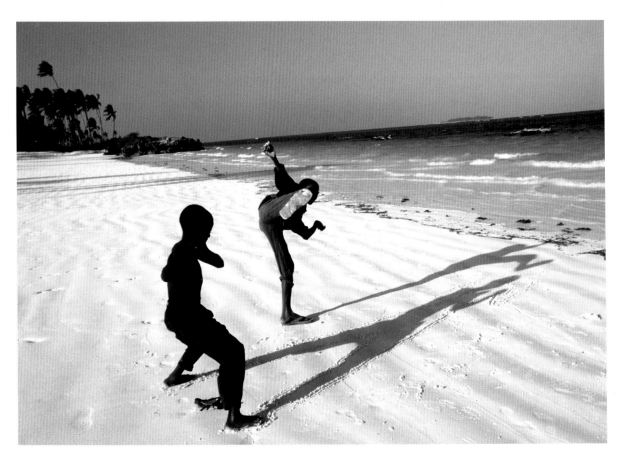

Left: These karate kids in Zanzibar were as fascinated by their elongated shadows in the late afternoon sun as I was. Fortunately, the sight of me encouraged them to show off all their best strikes and kicks.
■Canon EOS-1n with 17– 35mm lens @ 17mm; f/7 at $^1/_{250}$ sec; ISO 100 film.

Photography, as part of voyaging, is no longer about the discovery of new lands; it is the rediscovery of the world and of the self within it. It is hard to bring back surprises from your travels for there are hardly any places in the world not already trodden by other photographers. Travel photography is now, therefore, less about the thrill of the new and more about the satisfaction of contributing to the survival of the precious and fragile. In addition, the reliability of modern equipment has eliminated most of the problems that once challenged photographers working far from home.

Viewing it from Tao, travel photography is not a one-sided event in which bits of exotic life and topography are captured and brought

"The real voyage of discovery consists not in seeing new lands but in having new eyes." Marcel Proust

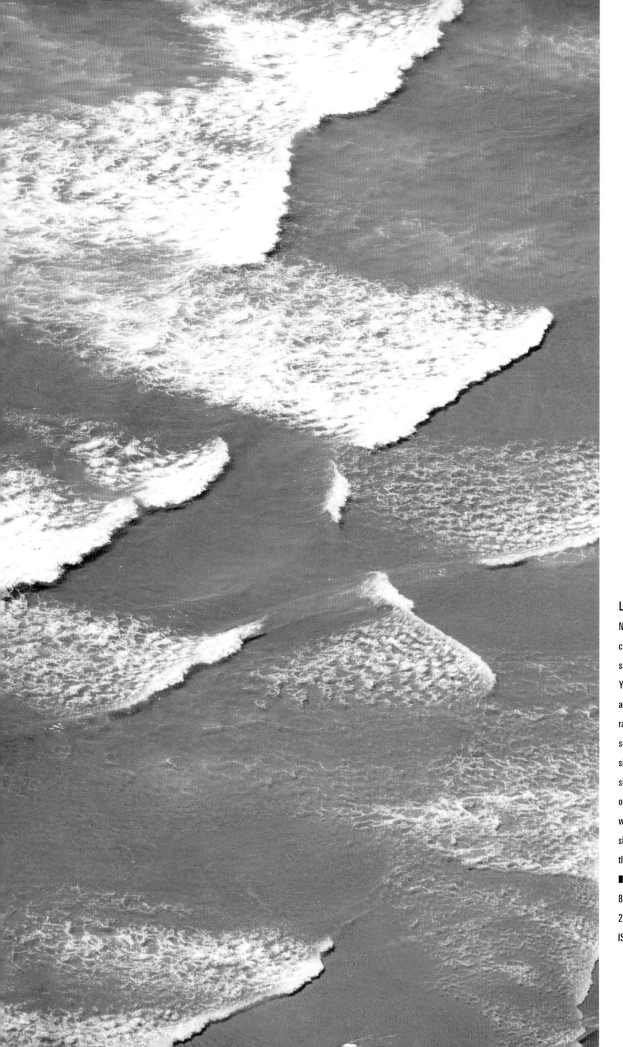

Left: In the extreme north of New Zealand contrary currents meet at a headland sacred to the Maori people. You can observe only from afar and what you see is a rare crossing of waves — something in which few sightseers see any significance. I overheard other tourists ask each other why I had taken so many shots — "It's only the sea," they were saying.
■Canon EOS-1n with 80—200mm lens @ 200mm; f/8 at 1/20 sec; ISO 100 film.

home on film. The Tao view is that photography is always part of a larger experience – that when an image records an exotic scene it also records the photographer's response and the interrelationships of the whole. Therefore, the wise photographer values both the interdependence of traveler and local person, the wise nurture the brotherhood of the visiting foreigner and the host culture. In short, Tao unhesitatingly recognizes that your travel destination is their home.

This has profound implications. The photographer is no longer merely a voyager who carries a camera, but

"If you don't back up your dreams with truth, you have a round-shouldered art." Andrew Wyeth

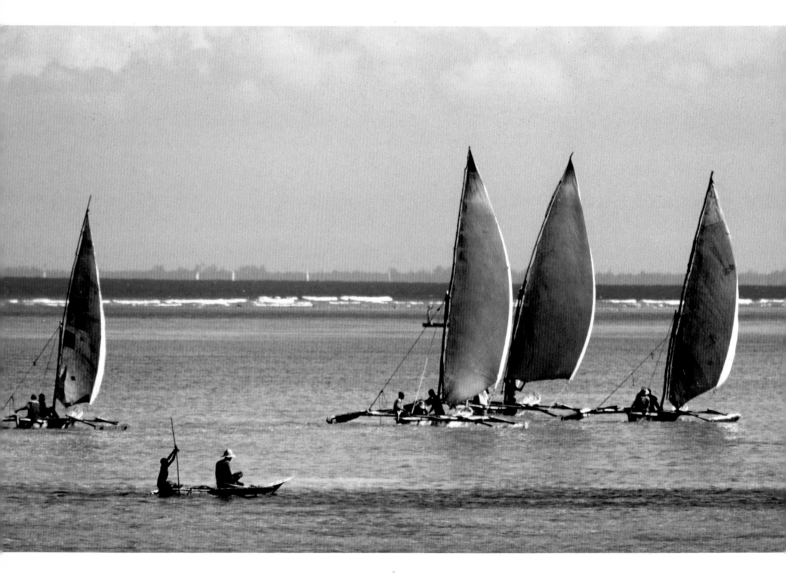

someone who is fully part of the entire tourism industry and an integral part of the forces shaping the future of fragile communities. In your travels you can, therefore, be part of the change for the better or for the worse. A full realization of this transforms your awareness of the dynamics and depths of what goes on around you. You will not ignore the fact that your holiday destination is protected by a barbed-wire fence from the local people. You will notice when people object to the way you dress and, instead of insisting on your right to dress as you like, you recognize your hosts' rights to dictate their own standards of decency. This way you can relax – and the more you relax the more you can receive.

Such facility comes from enhancing your awareness, not just of the visual but of all your modes of perception. Sometimes the best way to appreciate the life of, say, a busy market is not to look, to shut your eyes (but do not stand in the entrance to the fish market when you do it). Then smell the odors of people, and fruit, and cooking food. Listen to the shouts and laughter, to the tinkling of bicycle bells, to the pattering feet of small children running past. By feeling beyond what you can see you can see further than you can feel.

Aware of the larger context, the Tao photographer knows that having a basic vocabulary of greetings and phrases ("May I take a picture?") in the local language can be as important as accurate focusing. Knowledge of, and respect for, local customs and religious attitudes can do more for your photography than knowing which exposure setting is best. Smiles and honesty open doors that no amount of technical virtuosity could.

Being sensitive to Tao, the photographer knows that to feel superior is to be inferior; to conceal oneself is to be exposed. To travel in Tao is to respect other's homes as you love your own.

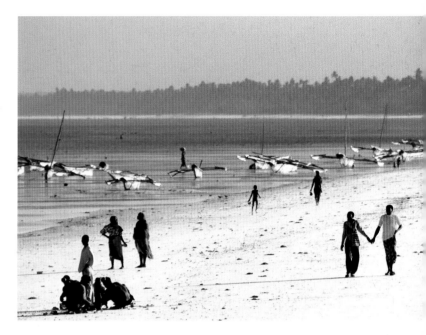

Opposite and above: Closing up the distance is not always the best approach nor, indeed, always possible. The charm of the scene here, on the Indian Ocean coast of Zanzibar, was the graceful ballet of people and their boats on the vast stage of the lagoon and beach. All you have to do is watch and wait, listening to the sea and the wind in the palms, while compositions work themselves out in front of you as people go about their lives – hard but not without its relaxed moments. ■Canon EOS-1n with 100–400mm lens @ 400mm; f/7 at $\frac{1}{250}$ sec; ISO 100 film.

"Be empty. Be still. Just watch everything come and go. This is the way of Nature." Lao Tzu

Travel Workshop

Everything you have learned about Tao needs to be put into practice when you travel and photograph at the same time. The numerous balancing acts you must negotiate start with the basics – packing your bags – and proceed through to the travel itself (rough it on local buses or hire your own four-wheel drive). In Tao, the unburdened body is the basis for an unburdened mind, and it is the lightened mind that best receives. In practical terms, this means traveling with the lightest but most versatile equipment possible.

For me, the greatest advance in travel photography has been the image-stabilized lens. This piece of equipment uses a system of sensors and a lens component that shifts a tiny amount to reduce the effect of camera shake. It minimizes the need for a tripod, even when you are working with long focal lengths, as with the images here. Unfortunately, stills image-stabilization is, at present, available only for Canon EOS cameras.

The wise traveling photographer, however, always looks after the weakest link. With modern camera equipment – amateur-grade cameras can outperform the best professional cameras of even the very recent past – and with today's excellent-quality color films, it is clear that the weakest link is in fact you, the photographer. It is

Above: Each evening, boys all over Zanzibar take advantage of the cool sea breezes to play football in the short time left before sundown. And every day I would watch and wait, enjoying the sight of the shapes, colours, and tonality changing second by second with the lowering sun. ■Canon EOS-1n with 100–400mm lens @ 400mm; f/7 at $\frac{1}{250}$ sec; ISO 100 film.

"Art is the demonstration that the ordinary is extraordinary." Ozenfant

not just that you may fall ill; the quality of your photography turns on your state of mind, your awareness, and your skill.

Tao photographers prepare themselves as carefully as they do their equipment. This means opening yourself to the unexpected as well as to unpleasant experiences, of learning the words and signs needed to communicate with your hosts, and of being responsible for the strangers whose lives you touch. This does not mean prejudging or creating structures into which you force your experiences. Rather, Tao photographers on their travels may be astonished by everything and surprised by nothing.

Below: The photograph is not perfect, but it is the best one from several days of observation. For a start, it was extremely difficult to get a picture in which the football could be seen. Then I liked the kicked-up sand being backlit by the sun — a lighting effect lasting only a few minutes. I wished for a boat to come into view in the background to "complete" the picture, but then I noticed men washing themselves at a standpipe. Another day, perhaps, I will be able to add the boat. ■Canon EOS-1n with 100–400mm lens @ 400mm; f/7 at $\frac{1}{250}$ sec; ISO 100 film.

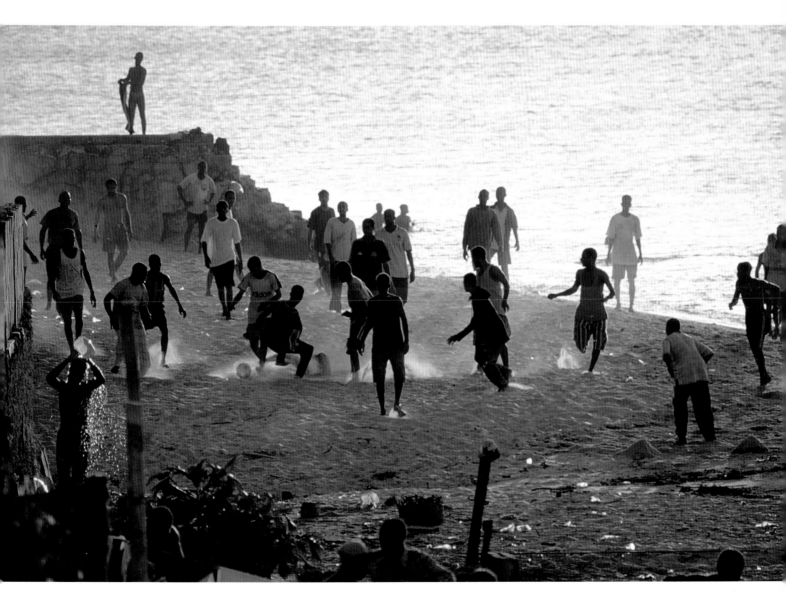

Braving the elements

The Tao of photography begins and ends in the landscape. Tao was aware and in awe of the landscape thousands of years before Western art recognized landforms as being something worthy of attention. When photography was invented, it turned its gaze immediately to the land. Photographing the land is at once the easiest and the most difficult of things. Easy because landscape appears to be a passive subject, one that does not become impatient or critical of you – it simply awaits your attention. The difficulty is that the numerous examples of superlative work are intimidating, while the total experience of landscape appears itself to be hopelessly beyond reproduction by photography.

Tao can point you to the Middle Way, to a path that is not necessarily easy, but one whose difficulty depends on your own desires and aspirations. The path sets out the broad band of activity between two extremes. One is of supreme effort, effort that may from time to time give you results close to genius. The other, polar opposite, is of no effort at all, and which, through a lack of a committed love or energy, produces mediocrity. Suppose you wish to create wonderful landscape photographs. To emulate great practitioners such as Ansel Adams, you would use a large-format camera, and devote weeks to climbing alone and braving the elements for that brief window of opportunity in which sun, sky, cloud, and landforms come together in stunning harmony. After that, you must process your films and make every print to archival standards. Or you could be like the tourists who were observed by Ernst Haas to lean out of their car to grab a quick shot of the Grand Canyon

Above: When the lake is full of concentrated caustic alkali, you do not argue and take what you can get. Unfortunately, the sun had gone in and a breeze was dissipating the vapor, so I had a long wait for the air to settle enough for a cloud to grow, hoping there would still be light to reveal it. ■Canon EOS-1n with 17–35mm lens @ 17mm; f/7 at $\frac{1}{250}$ sec; ISO 100 film.

"The nature of everything is open, empty and like the sky." Tibetan Book of the Dead

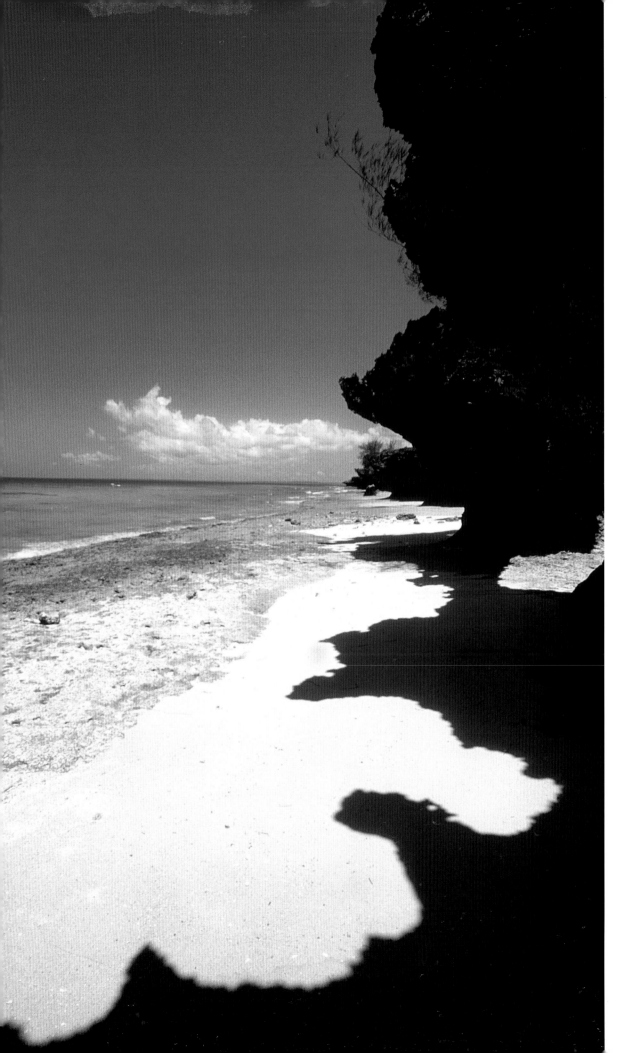

Left: These coralline, wave-sculpted rocks produce fascinatingly rich shapes and outlines that seem to transform themselves constantly as the sun moves through the sky (see also pp. 140–1). It is difficult to stop yourself photographing on this stretch of Zanzibar's coast as every view, every angle, and every perspective seems alive with forms and seductive shapes.
■Canon EOS-1n with 17–35mm lens @ 17mm; f/11 at $\frac{1}{125}$ sec; ISO 100 film.

Left: An unusually calm and cool day in late summer on the Aegean Sea was everyone's delight. From a distance, I watched as men and boys took to their boats to pass the time.
■Canon EOS-1n with 100–400mm lens @ 400mm; f/7 at $\frac{1}{250}$ sec; ISO 100 film.

Right: Normally, telegraph poles and wires are eyesores that disfigure the landscape, and such were my first thoughts on encountering this scene. But a little reflection revealed another aspect, since the scene also demonstrated the intrusion of man on the environment. A little walking around revealed a rhythm in the composition — one that created a tension between the aesthetics and the message.
■Canon EOS-1n with 80–200mm lens @ 150mm; f/7 at $\frac{1}{250}$ sec; ISO 100 film.

before driving off. Haas had returned to that same spot so many times looking for the perfect view, he had lost count of how often.

The Middle Way is far better than the plainness of no effort at all, and — because it is more achievable than supreme artistry and total sacrifice — it is also the most satisfying and balanced. It means that at times you must work very hard in search of the perfect viewpoint, suffering biting cold winds for hours waiting for that single sunburst to illuminate a valley. Yet at other times,

"Here, by the riverbank . . . I could keep myself busy for months without shifting my position, inclining sometimes more to the right, sometimes more to the left." Cézanne

it means learning how to take it easy, to accept that the world and the weather will not allow you to fulfill your wish. At which point, you may discover that almost as soon as you give in to circumstances, a vision opens up to you — it may not be what you

had planned, to be sure, but often it is far better. As a Tao photographer, you are able not only to walk the Middle Way, you are also able to understand that the active Yang approaches are most effective when they are balanced by the receptivity of Yin forces.

You are using Yang forces when you repeatedly visit a location until it yields the result you want – but this is often most effective when it is paired with the Yin approach of allowing yourself to work with chance occurrences, of falling into the flow of life. To the Tao, the difference between stubbornness and steadfastness is found

"The strange effects of perspective fascinate me much more than human intrigues." Vincent Van Gogh

only in the result – if you fail, then you know you were being stubborn. Conversely, the Tao sees failure as a step in another direction, not a step in the wrong direction.

Naturally, the Middle Way also applies to the technical approach. You can be using the Yang power of a large-format camera supported by a tripod. This will cost you mobility and convenience but it can yield results that are monumental in scale . . . when you

succeed in making a photograph. In contrast to this, a strongly Yin strategy – using a small, lightweight camera and minimal kit – allows you to travel more easily, giving rise to a fleeter, more immediate style of image. You can slink up mountainsides like a snow leopard, or sneak inconspicuously into narrow alleyways, and thus photograph more and further. But bear in mind that when you are presented with a fabulous scene or an epochal event, your canvas for recording it will be no larger than a postage stamp.

My response is to use the best in 35mm equipment and to expose on film that is as fine-grained as practicable – this means on occasion using black-and-white film that is as slow as ISO 25 and color film never faster than ISO 100. In this way, I manage to balance good image quality and portability on one side while accepting the limitations of working in poor light on the other.

And since I would rather enjoy a greater versatility in focal lengths than the limited range offered by larger-format equipment, so once more I opt to use the 35mm format. I can carry a good selection of lenses without being overburdened and still have space for all the other important things – such as a water bottle, a supply of food, a compass, and a pocket knife. All of these are easy to forget . . . but any one of them could be as important as a camera.

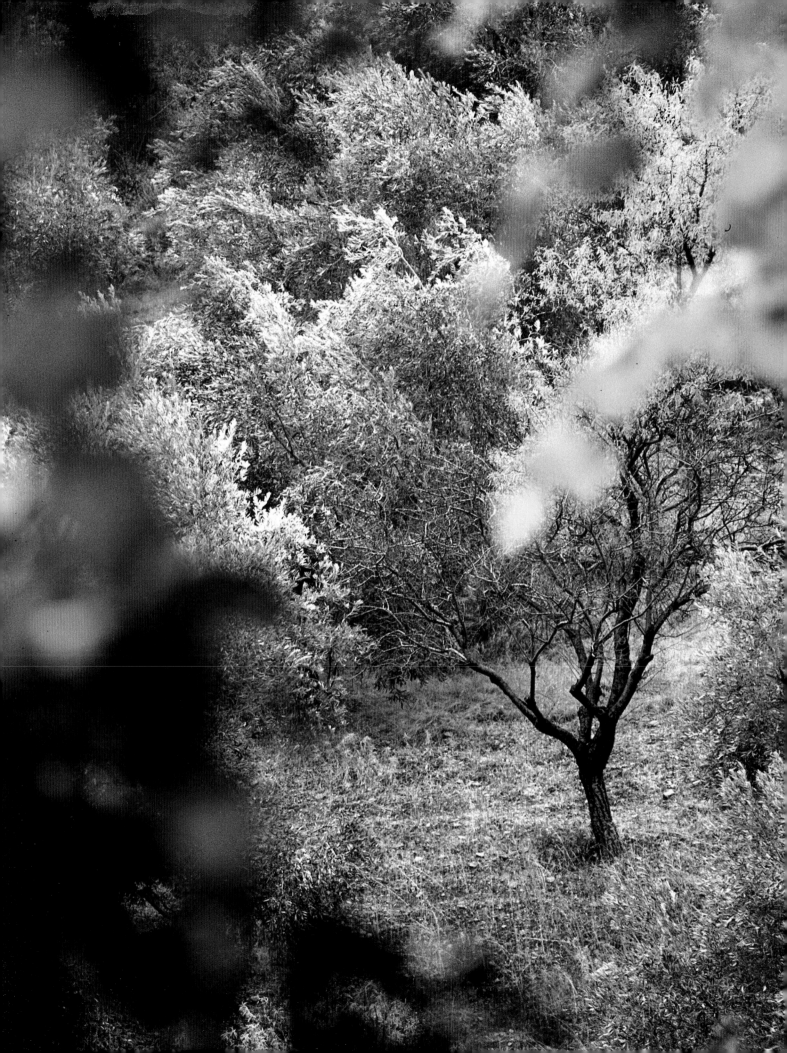

Landscape Workshop

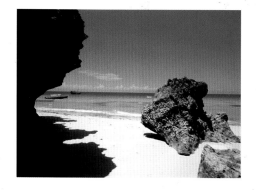

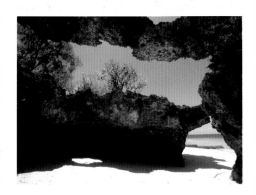

It is easy to be in the wrong place when the light is lovely and the right place when the light is dreary. But to Tao, every place is right for photography and all light is good light. The question is how to be present at the conjunction. It is splendid if you can return to one vantage point every dawn for a year to find the perfect light for that scene. But remember, when you work at a specific result, you are at the same time closing off other outcomes. The Tao photographer sees opportunities but does not force results. Instead of the relentless pursuit of a desired result, if you only hold yourself lightly but constantly aware, then there will come a "time when you sit up suddenly from your sleep and say, "This is it! We go now." And you will be right.

The Tao photographer understands that being awake means knowing when to sleep. At times you need to call on intense concentration and all your senses, not just the visual. At other times, you simply relax and wait. For the Tao photographer there is little difference between waiting and doing — for doing is but waiting done quickly. At its best, then, photography of the land is perhaps the depiction of Tao itself — even if it is only a fleeting taste — and that is the reward for photographing in Tao.

Above: While exploring a beach in Zanzibar (the same one as seen on page 135), I climbed through coves and scrambled into and out of holes, taking a picture almost every step of the way. "We made slow progress but lived in Paradise," as one explorer noted. Finally I lighted on a magical rock pool. ∎Canon EOS-1n with 17–35mm lens @ 17mm; f/16 at $1/125$ sec; ISO 100 film.

"Trying to understand is like staring through muddy water. Be still and let the mud settle." Lao Tzu

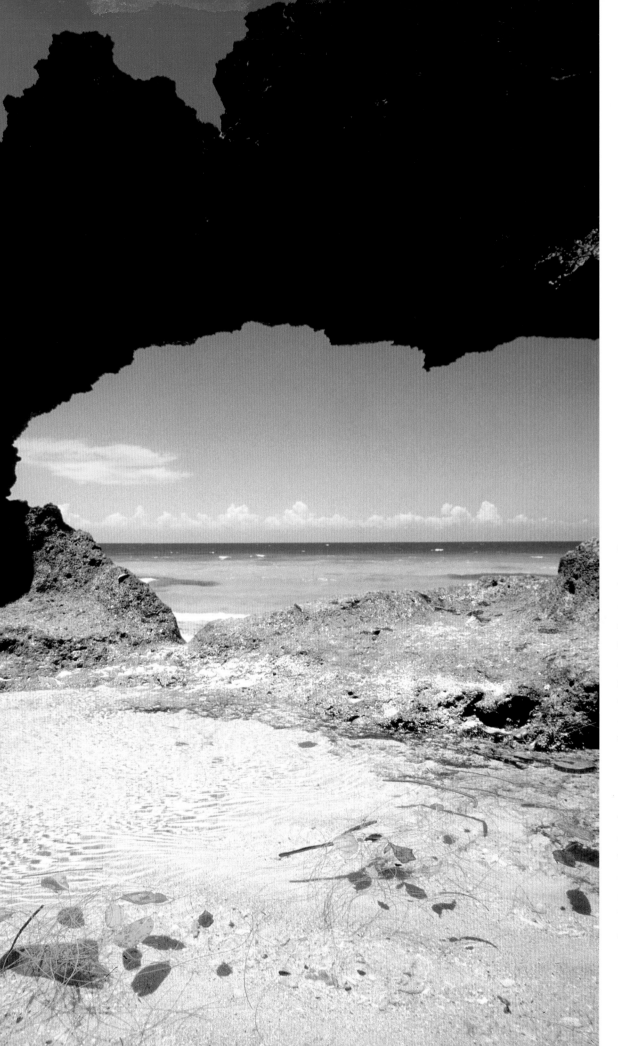

Left: This rock pool (also seen on page 7), with its little amphitheater, ideal for watching the dance of leaves and sticks spinning around in the sea breeze, is a Paradise. It brings together glorious light, delightful colors, an ever-changing view . . . and warmth. The danger is overenthusiasm, which leads to elementary mistakes. It is so easy to make errors in exposure measurement that I used two cameras, two lenses, and three rolls of film to ensure there were no mistakes.

■Canon EOS-1n with 17—35mm lens @ 24mm; f/11 at 1/250 sec; ISO 100 film.

Bibliography

The following are some of the books consulted in the course of preparing this work. For those wishing to learn about the Tao Te Ching in depth I recommend Wang Keping's scholarly but affectionate study (*see below*).

Barks, Coleman

The Essential Rumi (Harper, San Francisco, 1997).

Brendel, Alfred

Music Sounded Out (Robson Books, London, 1995).

Capra, Fritjof

The Tao of Physics: An Exploration of the Parallels Between Modern Physics and Eastern Mysticism (Shambhala, London, 1991).

Clark, Hiro

Picasso: In His Words (Collins, San Francisco, 1993).

Cleary, Thomas

The Essential Tao (Shambhala, London, 1992)

Vitality Energy Spirit (Shambhala, London, 1991).

Fondiller, Harvey

The Best of Popular Photography (Ziff-Davis, New York, 1979).

Haas, Ernst

Ernst Haas Color Photography (Abrams, New York, 1989).

Keping, Wang

The Classic of the Dao: A New Investigation (Foreign Languages Press, Beijing, 1998).

Kerst, Friedrich

Beethoven: The Man and the Artist (Dover, New York, 1964).

Roskill, Mark

The Letters of Van Gogh (Atheneum, New York, 1997).

Shefer, Dorothy

What Is Beauty? (Universe Publishing, New York, 1997).

Smullyan, Raymond

The Tao Is Silent (Harper, San Francisco, 1992).

Wyeth, Andrew

The Helga Pictures (Abrams, New York, 1987).

NOTE: The official way to transliterate Chinese into English is the Pinyin system, under which the word for "The Way" is rendered as Dao — not the commonly recognized Tao (which belongs to another system). Properly read, both sound the same, but only students of Chinese know that. It was felt that the general reader would be confused by references to Dao, to its central work as the *Dao De Jing*, the author of which is reputed to be Lao Zi. We have therefore chosen — with apologies to scholars — to use the common spellings of Tao, Tao Te Ching, Lao Tzu and Chuang Tzu.

Index

Acknowledgments

In the best of Oriental traditions, the enlightenment which led to this book arose from some light-hearted wordplay and joking around, for which I am pleased to thank my daughter Cicely. And in the best traditions of publishing, the idea seemed so obvious we were astonished to learn that no one seems to have thought of it before. And true to Taoist traditions, while the book was written in under three months I realize now that I've been thinking about it for well over fifteen years.

Therefore, over the years many, many people have contributed to it — even if I did not realize it at the time. It feels right that I should reach back over a long time to thank everyone who has ever shared their thoughts with me, in particular the late Jozef Gross and the late Andrew Mannheim, both of them commentators of genius on photography in their very different ways, who taught me that photography was more than just taking photographs. Variously for their insights, enthusiasms, knowledge and disagreeing with me on photography, I also wish to thank, amongst many, Peter Korniss, Eddie Ephraums, Michèlle Bogre, Nigel Skelsey, Erla Zwingle, Carolyn Watts, and Kristina Rassidakis.

At Mitchell Beazley, Executive Editor Judith More and Executive Art Editor Janis Utton deserve thanks for believing in the book, although none of us had any idea what was going to be in it. Thanks also to Senior Editor Michèle Byam for so steadily steering the project to completion.

I am also grateful to Ilford Limited for assistance; to Nikon for their excellent LS-2000 scanner; to Photopia for the superlative ArtixScan 4000 scanner; and to Linotype-Hell for the Saphir Ultra II scanner.

But to Wendy, no thanks can be enough for her love and support, which made this book and all my work at all possible.

———————

Tom Ang